JESSICA STOCKHOLDER

KISSING THE WALL : WORKS, 1988–2003

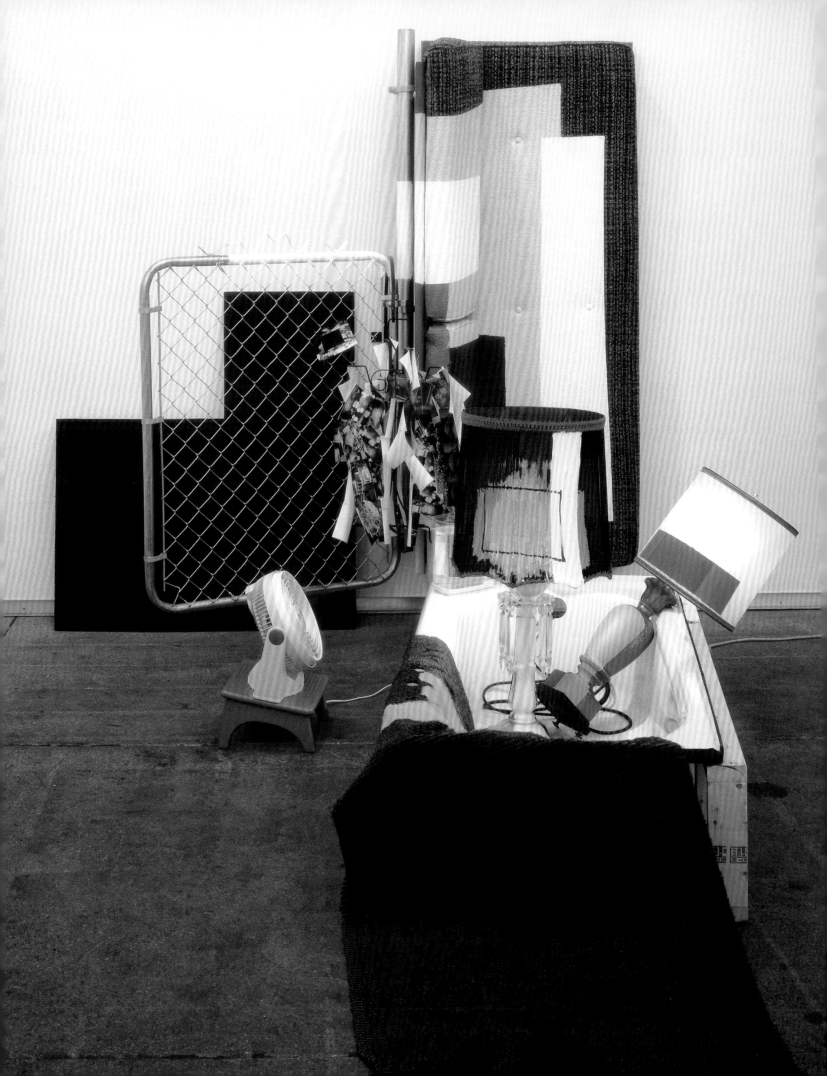

JESSICA STOCKHOLDER

KISSING THE WALL : WORKS, 1988–2003

NANCY DOLL

TERRIE SULTAN

with essays by

ELSPETH CARRUTHERS and MIWON KWON

BLAFFER GALLERY
the Art Museum of the University of Houston

and

WEATHERSPOON ART MUSEUM
The University of North Carolina at Greensboro

Published in conjunction with the exhibition

Jessica Stockholder, Kissing the Wall: Works, 1988–2003

Blaffer Gallery: September 18–November 21, 2004
Weatherspoon Art Museum: February 13–May 8, 2005
The exhibition and publication were co-organized by Blaffer Gallery,
 the Art Museum of the University of Houston, and Weatherspoon
 Art Museum, The University of North Carolina at Greensboro.

Blaffer Gallery, the Art Museum of the University of Houston
120 Fine Arts Building
Houston, TX 77204-4018
713 743 9530
www.blaffergallery.org

Weatherspoon Art Museum
The University of North Carolina at Greensboro
Spring Garden and Tate Streets
Greensboro, NC 27402-6170
336 334 5770
weatherspoon.uncg.edu

Available through
D.A.P./Distributed Art Publishers
155 Sixth Avenue, 2nd Floor
New York, New York 10013
Tel: (212) 627-1999 Fax: (212) 627-9484

This exhibition and publication is generously sponsored by: Altria Group

 Altria

Major support was provided by The Andy Warhol Foundation for the
 Visual Arts, Houston Endowment Inc., and the National Endowment
 for the Arts, a federal agency.

Library of Congress Control Number: 2004103212
ISBN: 0-941193-22-5

Jacket front: *Kissing the Wall #2,* 1988 (see plate 1)
Jacket back: (see plate 52)
Frontispiece: (see plate 47)

Production Coordinator for Blaffer Gallery: Susan Conaway
Proofreading for Blaffer Gallery: Polly Koch
Editor for Marquand Books: Marie Weiler
Proofread by Sherri Schultz
Indexed by Jennifer Harris
Design and composition by Susan E. Kelly, Luminant Studio
Separations by iocolor, Seattle
Produced by Marquand Books, Inc., Seattle
 www.marquand.com
Printed and bound by C&C Offset Printing Co., Ltd., China

CONTENTS

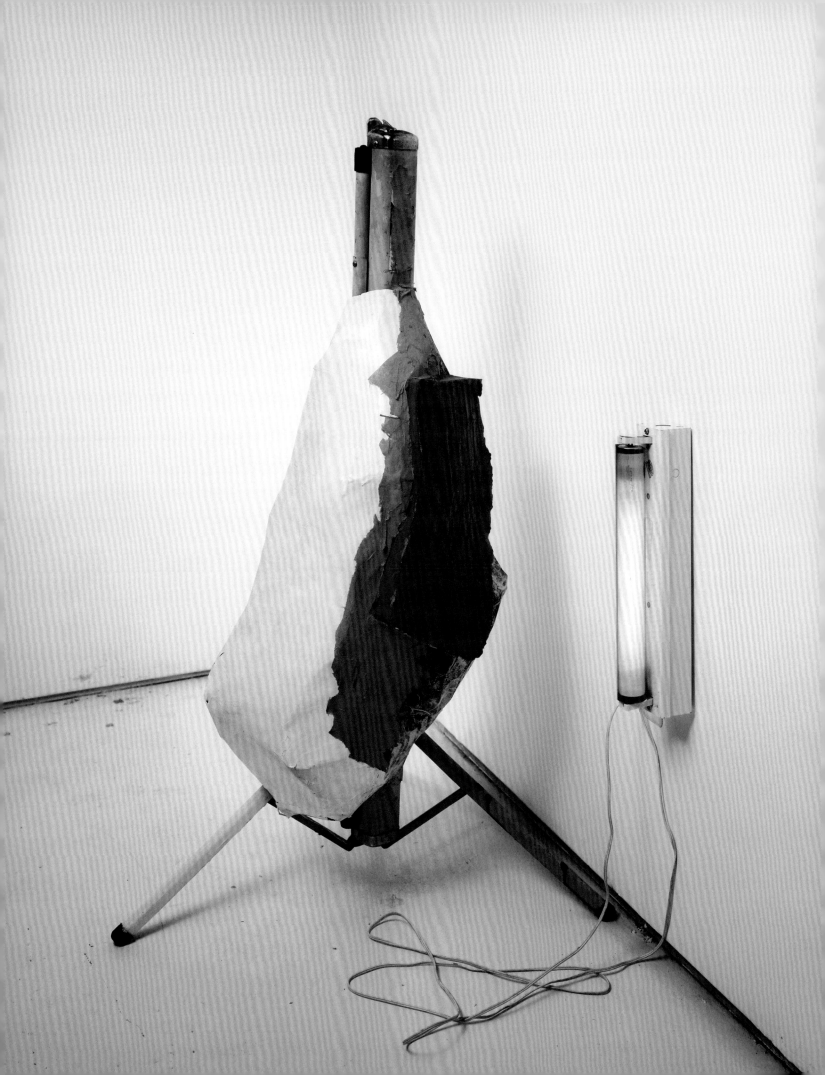

Nancy Doll and Terrie Sultan

INTRODUCTION AND ACKNOWLEDGMENTS

STEPPING INTO AN EXHIBITION OF JESSICA Stockholder's work prompts memories of shopping at Kmart, greeting a child's room full of colorful toys and games, visiting a lighting store whose stock is in disarray, and walking down Broadway after the Macy's Thanksgiving Day Parade. Situated somewhere between home and Home Depot—with innumerable detours—Stockholder's art is optimistic, energetic, visually stimulating, and formally and intellectually rigorous.

Throughout her career, Stockholder has balanced production of the monumentally scaled, multidimensional, and highly theatrical site-specific installations for which she is largely known with self-contained assemblages and various two-dimensional works that reflect a more intimate, human scale. It is through these assemblages (formal "essays" in which the artist processes her ideas about materials and composition) and her collages and monotypes (intimate, autonomous "sketches" in which the artist explores the pictorial tradition of framed space) that we can gain further insight into Stockholder's creative process.

Verbs, particularly action verbs, seem to be the most apt part of speech to describe Stockholder's art, which has been said to overlap, turn, hover, bulge, and kick. Her art also misbehaves by defying any and all attempts at categorization or even description. Her work further suggests the function of language in the way that individual elements have meaning unto themselves but carry other associations based upon their context. Just

as by talking we sometimes clarify what we think, Stockholder's work assumes form and meaning as it shifts from one thing to another, compelling us, as we view it, to make sense of the space we move in. Not only does her work connect the dots, it also links colors, forms, and spaces into relationships we could not have imagined.

In 1983, the year that Stockholder began graduate studies at Yale University, she created *Installation in My Father's Backyard* [Plate 2]. This became a prototype for all of her subsequent explorations as she developed a vocabulary that fused two seemingly incompatible disciplines, painting and sculpture. In 1988, *Kissing the Wall #2* [Plate 1], a projection screen wrapped with paint and incorporating a light pointed at the wall, she initiated the series of smaller assemblage objects that would become the cornerstone of her subsequent work.

Profusion, multiplicity, and contradiction characterize Stockholder's approach to art making. She structures fusions of found objects—commercially produced textiles, construction materials, household items, and bits of everyday stuff—as shapes and lines in space. The use of the commonplace is emblematic of Stockholder's creative process. Building upon the creative trajectory of Robert Rauschenberg, her compositions challenge cognitive and emotional distinctions by blurring categories such as object and environment, or decorative beauty and practical use. Trained as both a painter and a sculptor, she takes a surprising hybrid approach to art making that is grounded in sophisticated theoretical content, a spirit

1

Kissing the Wall #2, 1988
Slide projector screen, newspaper, plaster, oil and acrylic paint,
fluorescent tube with purple sleeve, wallpaper
51 in
129.5 cm
Collection of the artist

of adventure and exploration, and a sly sense of humor. Stockholder's work packs the color, shape, and surface of conventional painting into the space, volume, weight, and mass associated with sculpture. The found objects and raw materials she uses are commonplace, but she assembles them in such a way as to reintroduce magic and possibility into things we normally perceive as possessing little or no aesthetic value.

In 1965, Donald Judd wrote, "Half or more of the best new work has been neither painting nor sculpture."[1] Stockholder is quintessentially of this historical paradigm, and her innovative work has been influential to a younger generation of artists. Her sculptures and installations are fully informed by historical awareness, and her influences vary widely, from Henri Matisse, Paul Cézanne, and the Cubists to Clyfford Still, Frank Stella, New York School hard-edge painting, and Minimalism. Her bias toward physicality and a materialist's understanding of artistic modernity also finds its roots in Allan Kaprow's 1960s Happenings and the post-Minimalist "scatter" art of Robert Morris and Robert Smithson. Through her tutored conceptual lenses, Stockholder synthesizes these various influences to produce original, innovative, and intensely visual essays on the theme of forms in space.

The exhibition **Jessica Stockholder, Kissing the Wall: Works, 1988–2003**, takes its name from the seminal 1988 piece mentioned above. The period of the exhibition is framed, on the one hand, by this momentous development in her work and, on the other, by recent work that has moved away from the wall to stand freely in space, another important step in her artistic exploration. Seventy-four works have been selected for the catalogue to exemplify the diverse range of Stockholder's aesthetic and her cerebral synthesis of artistic and stylistic precedents that, combined with her own visual impulses, has resulted in a unique and highly important body of work.

Intelligent, articulate, witty, thoughtful, and generous, Jessica Stockholder has been a pleasure to collaborate with. We have both thoroughly enjoyed and benefited from our conversations with her. Elspeth Carruthers and Miwon Kwon have contributed two insightful essays on Stockholder's work and practice, and we thank them for their interest in participating in this catalogue. Katie Robinson Edwards and Rachel Freer worked tirelessly on the annotated chronology and exhibition and publication history. We are grateful to Stockholder's gallery, Gorney Bravin + Lee, for its ready and enthusiastic help with countless details of the exhibition, and we warmly thank those who lent works to the show. We also wish to thank the staffs at both of our institutions, whose dedication and professionalism were demonstrated at all phases of the project. Our funders are to be sincerely thanked, as their support has made this project possible: Altria Group, the Andy Warhol Foundation for the Visual Arts, Houston Endowment Inc., and the National Endowment for the Arts, a federal agency.

1. Donald Judd, "Specific Objects," in *Arts Yearbook VIII* (New York) (1965), cited by Barry Schwabsky in *Jessica Stockholder* (London: Phaidon Press Ltd., 1995), p. 52.

2

Installation in My Father's Backyard, 1983
Installation, private residence, Vancouver

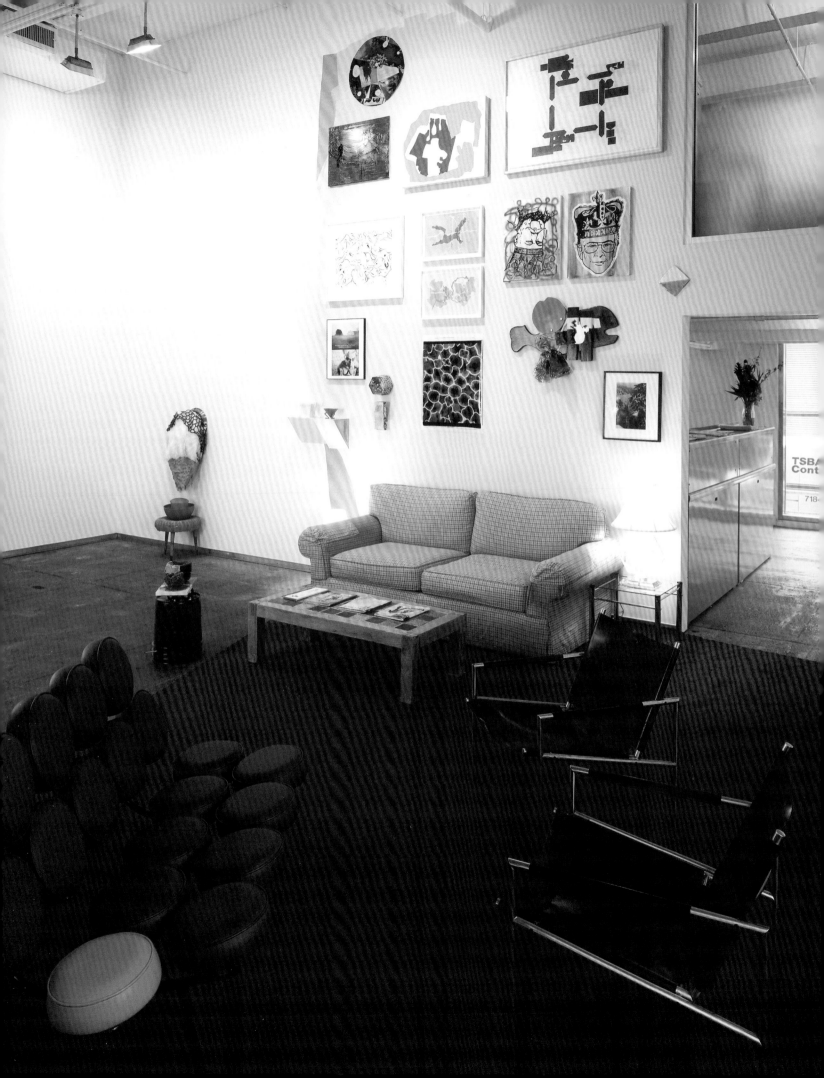

INTERVIEW WITH JESSICA STOCKHOLDER

Jessica Stockholder's 2003 exhibition at Gorney Bravin + Lee in New York introduced several new ideas and directions. Nancy Doll and Terrie Sultan met with Stockholder prior to the opening to discuss her new work.

TS We want to talk today specifically about the new work, especially the concept, and then cover some more general conceptual or theoretical things. So, we are live and recording at Gorney Bravin + Lee gallery in New York, with Jessica Stockholder, Nancy Doll, and Terrie Sultan, on Thursday, October 9, 2003.

ND We are sitting around the coffee table in what Jessica refers to as the "living room situation" at the entry of the exhibition [Plate 3].

TS Let's talk about the coffee table. When you were visiting me in Houston this year and were talking about your upcoming show at the gallery in New York, you said that this represented a move forward for you and how you were thinking about architectural spaces in a different way, more human. You mentioned that you were planning to make a seating arrangement and would invite other artists to make work. How did this come about?

JS I was feeling ensnared by the large scale of Chelsea galleries. I love to have my work address particularities of space, but I don't want to feel obliged to make big things all the time. This was the first exhibition of studio work that I considered as a whole single event. Usually I make pieces, they accumulate, and I have a show of them.

This time I actually had an idea about what "the show" would be. It's not necessary to create a "show"; individual works are fine, too. It is perfectly respectable to make things that exist as mobile things in relationship to different contexts as they move around in the world. But I don't think people make anything without assuming some kind of context. The work I make in the studio assumes the white cube as its context. The studio work, in contrast to the installation work, is a more idiosyncratic, personal, intimate kind of experience for the viewer and me. I am alone in the studio making it. I try to arrange my life so that there isn't time pressure on me in the studio. I don't plan the work. It is a more meandering kind of process.

TS So it is really personal. It is between you and your materials, and less about the particularities of space.

JS My work definitely assumes a white cube, and a Chelsea gallery demands a big, splashy event. I could have made a bunch of small things and dotted them along the wall; that would have been fine. But since my excitement has to do with commanding space, that didn't appeal to me. I nevertheless wanted to bring a more intimate experience to the public without relinquishing some kind of acknowledgment of, or play with, the space. So I had this idea of a salon-style hanging of little things in relationship to a living room furniture situation [Plate 4], and having that juxtaposed to a white cube style of hanging where things are cleanly presented in a "neutral" space. Then I realized I could invite other

3

Situation created for the exhibition **Table Top Sculpture**, 2003
Gorney Bravin + Lee, New York

people to help fill up the salon-style situation. This gesture addresses my concerns about intimacy, and it's another way of addressing context. The other artists who contributed to my show are all part of the landscape that I work within. They are just as much a part of the context I think within, and that my viewers think within, as the history of white cube display.

TS Are these all people with whom you have personal relationships?

JS Some, but not all. They all are relevant to my life as an artist. I think that the way we define success in art making requires that the artist be unique, special, different from other people, and for that reason it is difficult to relax and just enjoy the similarities and connections

4

Situation created for the exhibition **Table Top Sculpture**, 2003
Gorney Bravin + Lee, New York

between works of different people. Hanging this show was a nice opportunity to enjoy the flow between what I do and what other people do. I feel myself to be part of a dialogue that is about a lot of different things. This collection of work brings some of that dialogue into this room.

ND You invited people to show with you who work in widely different formats, with widely different materials.

JS I'm not focused on just one form of art practice. I am interested in the larger parameters that define art.

TS There is still a lot of gesture in your work, which goes back to being a painter. It was fun seeing work by both David Reed and Jim Hyde [Plate 4], both of whom use symbolic or codified gestural brushstrokes, and how that related to the way you painted the wall. There is that part of your work that is rooted in Abstract Expressionism.

JS When I was a student, Abstract Expressionism was taboo, and it still is even today. Many of my colleagues understand their whole enterprise to be in opposition to Abstract Expressionism. I have some feeling for that position; we don't live in little bubbles all by ourselves in our studios. Translating our interior landscapes to canvas may not be the most interesting subject in the world all by itself. We are, however, each of us, possessed of a unique subjectivity, and what we make of ourselves in the world might indeed be very important to others. I think it is misguided to believe that just because evidence of the hand is missing from artwork, that feeling and evidence of subjectivity are erased. The gesture of placing an object in a room is not so far removed from making a gesture with a brush. Both are created by a single person whose name is on the wall and who claims ownership.

ND It is the assertion of the individual, the choice and decision, and the expression that are important.

JS One of the great things about Western culture is the degree to which individual minds and feelings, will and judgment have been recognized and valued. The recognition of individuality is extraordinarily important; I value that. The white cube speaks to this valuing of the individual. This is a very contemporary and modern way to understand life. Not without its problems, of course!

ND So, in a sense, in the living room atmosphere you conceived, you married your two practices—the site-specific installations and the more autonomous studio works, the public and the private.

JS I am calling this living room end of the room a "situation." I don't think of it as an "artwork." It is not a thing to be looked at. I'm altering the situation of the display.

TS Isn't that similar to what you do when you work in a space for a bigger, site-specific work?

JS I don't think there is a clear line separating the two, but this seems slightly different to me. This situation doesn't propose that its borders, however difficult they might be to find, frame off the work of a single subjectivity.

TS Perhaps it is because you are encouraging people to actually live in this space. I know that in the site-specific pieces you want the viewer to experience the space, but always from the perspective of standing, looking, or passing through.

JS It is interesting that you say that, because it's true and not true. Two minutes ago in this interview, I would have said the same thing. But in many recent installations, I have included couches and bleachers. In those works the viewer is perched as part of the work. This "situation," however, does make room for us to live here. It makes sense to sit and talk here as we are doing. In other installation works, my viewers were on stage, and I was posing the viewer as part and parcel of the work in a heightened self-conscious way. In this work self-consciousness is encouraged in the viewer, but the viewer isn't posed as an actor.

TS Here you are really asking people to participate.

ND You have used couches and beds in your work in the past, but this becomes a kind of waiting room where people come and gather, and look at the collection, and then go into the rest of the show.

JS Yes, I like that you can come in and sit down here on a comfortable chair in front of a coffee table and look out into the gallery where there are sculptures made out of tables and lamps similar to the ones used where we are sitting. In this "situation" the lamps function to light things, while in the sculpture the lamps are used for a whole set of different reasons having to do with fantasy life and the fluid significance of things made. I love the gulf created between the coffee table here and the table over there that no longer functions primarily as a table [Plate 5]. The juxtaposition between this living room "situation" and the white cube display of my sculptures highlights the different kinds of wanting that different kinds of display inspire and the different kinds of pleasure that objects can elicit. Having artwork in your house above the couch is one kind of a pleasure, where you can sit and relax and look at it; you can see it day after day. The white cube gallery space is a public experience; you have to control yourself, just like the space is controlled. The art looks beautiful, authoritative, and impressive, but quite separate from you, bigger than a single you. These are two very different kinds of experience, and I want to address the schism between them. We show things in white cubes and have conversations about what they mean. We don't spend a lot of time talking about the fact that the gallery is a store where things are being sold, and perhaps for good reason. The value of art cannot be summed up with a price tag. But art is sold; my art, at any rate, is expressed as objects, and people own them like they own nice furniture. So I've put this piece of fancy furniture, the marshmallow couch, in the show; I think it's quite similar in some ways to my sculpture.

ND Where did you get the sofa?

JS From a furniture store in Brooklyn called David Allen where, curiously enough, he regularly shows art together with the furniture he is selling. When I first conceived of this show, it was my fantasy to include a marshmallow couch. It is so fanciful, kind of ridiculous for a sofa. It is not particularly comfortable; it is all about design and looks. It overlaps the territory of sculpture. It, like my work, engages territory where there is slippage between categories. And then I changed the color of the covering on one cushion so that there is a little lime green circle hovering over the red carpet. This small intervention in

2003
Tree trunk, two radios, ceramic bowl, pink plastic bucket, three lamps, fake fur, acrylic paint, aluminum/tar flashing, purple power bar, silicone caulking as glue
89 × 35 × 46 in
226.1 × 88.9 × 116.8 cm

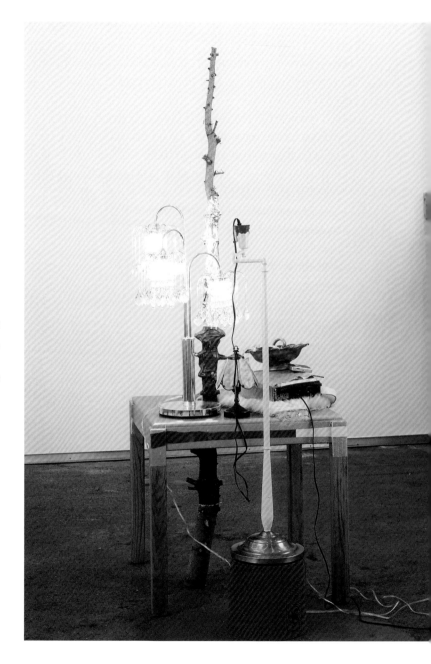

the living room here creates an event similar to that one happening across the way there in the white cube. George Nelson, a designer at Herman Miller, designed that couch, which the company now produces in multiples, and I've messed with it a bit. I'm exploring the boundaries and framing of the single subjectivity in the making of things. The question is, "How is George Nelson's designing the marshmallow couch different from my making a piece of sculpture?" Well, in part it is that the couch is useful. But it is only kind of, sort of useful. People aren't buying it because it's useful.

TS This created environment puts the viewer in a different relationship with your work. I can sit on the couch and look at the sculpture in the gallery space from a distance. This is not the way one normally approaches a sculpture show. Usually the viewer has to walk into the space and is forced into a one-on-one relationship with the objects. I can also see how easy it is to sit here and view the sculpture. It flattens everything out, but also demonstrates the relationships between the pieces that you don't get when you are walking around each one. Is that something you thought about?

JS No, not really, but that sounds good. I think that's happening here. I was more focused on making a juxtaposition between the public and private. Galleries are not spaces to live in, but here I've tried to make a little room for "living." There is something painful about being in a neutral gallery space, but those feelings do yield riches, and so we continue to use this convention to display a very complicated art thing. There is poignancy in the space of the white cube, power and authority asserted, attention demanded. The nature of white cube display makes clear that looking at art is work—not just play— that it's important. But it is also painful to be deprived of an intimate experience with the art, and here I'm trying to make some room for intimacy.

TS To delineate the space of your "situation," you painted the wall, using very expressionistic brushwork and a warm color palette. Did it occur to you to paint other wall areas within the white cube so that the more traditional gallery space would be altered and relate to the couch area?

JS No, I wanted to oppose and contrast these two different modes of display. The painting on these walls functions both as décor for a domestic space and also as expressionistic gestural painting. Houses tend not to be decorated like this. The painting on the wall is not one thing or another; it is confused as to what role it wants to play. I like that. The impulses that go into home décor are not miles apart from art making impulses.

ND You talked about your studio work as being domestic pieces, which have always been an aspect of your work, the gathering of materials related to the home. But in this case, the domestic nature, the content of the work, relates to a domestic setting in ways that in other work might not have been as important.

JS Yes, but the word "domestic" always rattles me a little bit. The domestic and domesticity are associated immediately with women and considered as low in the hierarchy of cultural concerns. Domesticity is not seen to be as important as work, politics, and intellectual life. So I always get rattled to have my work labeled with the word "domestic." And that word does often end up functioning as a label; as such, it tends to limit rather than expand the kinds of thinking brought to the work. We all have domestic lives, women and men. People's desires to buy and accumulate are tied to domesticity.

ND There is a private use, private consumption. Showing your art in the gallery would be seen as public consumption.

JS And I am interested in the relationship between things being privately and publicly consumed, and things being privately and publicly produced, and how that relates to the question of originality. Yes, we have a tradition of an artist's being in the studio alone, producing something that reflects private thoughts, concerns, and passions, and I experience my work that way. But I don't live alone, and I don't think alone. All my experience is tied to a whole network of people and history.

ND Is this the first time you have made sculpture [Plates 8 and 9] that is totally freestanding?

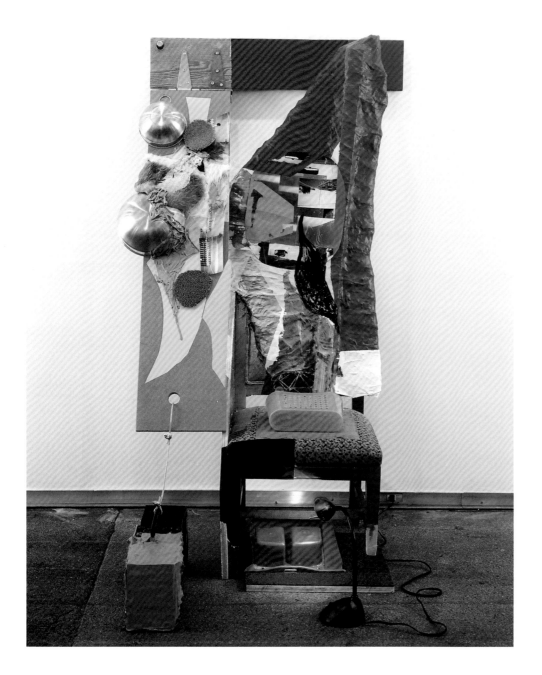

6

2003
Chair, radio, purple quartz light, wool, steel bowls, photographs, carpet,
hardware, papier-mâché with plaster, plastic elements, wire mesh, power bar
68 × 40 × 45 in
172.7 × 101.6 × 114.3 cm
Collection Clifford P. Diver, Lewes, Delaware

JS It is. I am not sure why I decided to do that just now.
My work developed into installation from painting. I
felt unhappy about the coolness and the remove that the
white cube exhibition space brings to art. When I fin-
ished graduate school, I didn't have a big studio. I was
working in my apartment. I didn't want to make big
installations in relationship to my living space, but to
make something that would have no audience seemed
pointless. So I developed a way of working that was
mobile. I was able to do that with pleasure by finding
a way to make sculpture that created a charged space
between itself and the wall. The energy that resulted from
this countered the sense of remove that I was upset by.
My work has always grown from a contemporary shared
dialogue about the relationship of art to the white cube,
a dialogue that is often understood as an antagonistic
battle between the two. I'm not sure that there is a battle
to be won and lost, and recently I have begun to under-
stand and value the pleasure that is generated by owner-
ship. This is a very human pleasure, as rich and full of
resonance as the pleasure we can take in form and struc-
ture, or color. I think that ownership is also related to
framing in painting. And I am obsessed with framing.

ND That is interesting in the context of this exhibition
because we start with *Kissing the Wall #2* (1988) [Plate 1],
which began a body of work for you that was a seminal
moment that put you onto a course for many years of
a certain type of practice, and now you are coming to
a point of possibly leaving that. . . .

JS Or just letting it break open.

ND Yes, letting it break open. I don't mean leaving it
behind. Moving it into other possibilities.

TS By breaking away from the wall, you have changed
the viewer's relationship to the work. In the earlier studio
works, the viewer engages with the work frontally with-
out being able to fully circumnavigate. But now we can
have full access. We are more in the object, even if it is a
small studio piece, which is more like the experience of
the site-specific work.

JS My studio work developed against the wall as a devel-
opment from picture making. Pictures are flat, just like

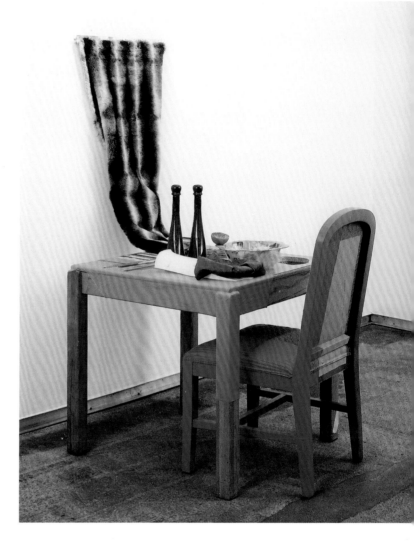

7

2003
Wooden table, two blue glass bottles, flipper, painted shower curtain, acrylic
paint, pink upholstered chair, fur on hinge, plastic bowl, plastic orange,
fake fur
58.5 × 53 × 30 in
148.6 × 134.6 × 76.2 cm

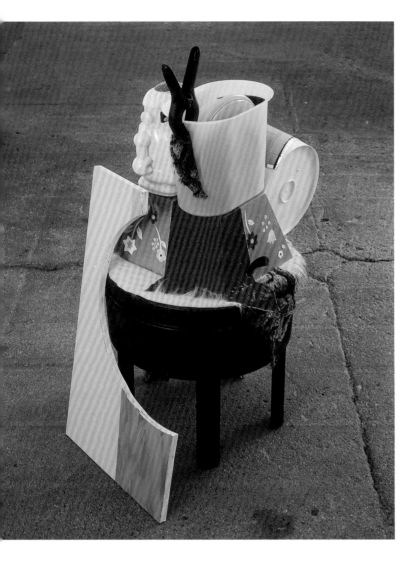

8

2003
Black plastic composting base, green plastic containers, pink wooden box, plywood, plastic clamp, fabric, fake fur, aluminum/tar flashing, plastic robot toy, acrylic and oil paint
42.5 × 20 × 27 in
108 × 50.8 × 68.6 cm

9

2003
Metal file cabinet base, plywood, acrylic yarn, plastic basket, yellow plastic bowls, pink plastic tub
27 × 17.5 × 24 in
68.6 × 44.5 × 61 cm

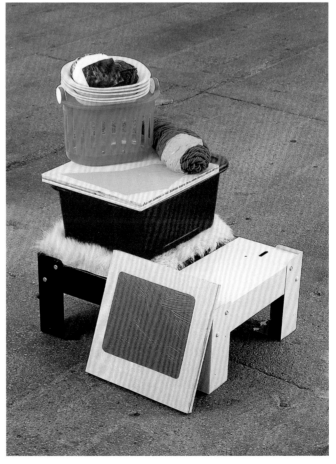

the flat walls of the buildings that hold them. They are, in this sense, site-specific; they have a very particular relationship to context. My work has functioned very similarly in relation to the wall. In these freestanding works, I am not in such tight control of the picture-making aspect of the work.

TS Was that freeing or scary?

JS I have really enjoyed it. Several years ago I began thinking about how to best create and show smaller work in the confines of a gallery, how to enjoy the space, take pleasure in the space, and not have scale, for example, dictated to me by the space. Part of my response was to find a way of domesticizing part of the space. For me it feels more difficult and slightly uncomfortable, less crisp and gorgeous in a formally structured way.

TS I was reading in your interview with Lynne Tillman in the Phaidon catalogue about your use of color, especially the difference between color painted on a surface as opposed to the saturated color in yarns and plastics and the other found objects that you use. It occurred to me that you are an incredible colorist. Your use of color is perhaps the most appealing aspect of what you do [Plate 10]—your understanding of how color actually works for the person who is looking at your art.

JS I love color because it is localized and fixed to an object as a physical thing, on the one hand, but can appear to jump and move in the air, on the other. Color can be fanciful; it functions well as a parallel to inner life. Our feelings are not concrete—they don't have physical form—but that doesn't make them any less real. It is difficult to articulate what makes color exciting, just what one can do to make color exciting or interesting. Color is not very popular as a place to focus conversation or intellectualize because it is so difficult to articulate. It is subjective. We don't know if we see color the same way. We know that some of us don't; some people are color blind. None of this eclipses the fact that color is evocative and that we have powerful and meaningful responses to it.

ND Color is so linked to the brain. It creates a synesthetic reaction, triggering so many different sensations. There has been a lot of work done with brain function and perception of color.

JS There are many books about color that try to make sense of it. But all of that structuring and science doesn't fully explain the complexity and subtlety of our experience or why color is exciting and interesting to us. David Bachelor has written a book called *Chromophobia*. Have you read that? He talks about the place of color in culture and how color is associated with the lower class and white with the upper class.

TS It's true that it is hard to talk about color, even in a formal way, because it is so subjective. Why do people respond to certain colors?

JS As a kid, when I first started making things, I was obsessed with red and green. There is an exciting energy between those two colors. I think there is something very sexual about red and green. Together they are vibrant and exciting. I don't think it is an accident that a lot of berries and fruits are red and orange, in complement to the green of foliage.

ND Do you feel that you are gravitating back toward painting in a certain way?

JS My work has been and always will be laced with painting.

TS Delectable is a word I could use to describe a lot of your work. The color operates in such a way that you can really appreciate it through a number of your senses, taste being one of them. There really is something very physical, yummy, about this work.

JS I value pleasure and appetite in art, and I find that the body is fully engaged in intellectual life.

TS That's also apropos for your work. It's eye candy, in a positive sense. It's appealing to have this enter your head through your eyes.

ND That's something you don't see much of these days. That's why your work slows the viewer down, because it is so gratifying to look at.

JS There are those who think that art should be pleasing—that it is defined by its physical sensuality and pleasure—and there are those who think pleasure in art to be "eye candy" and, as such, devoid of real intellectual content or sustenance. The antagonism between these two points of view is not necessary. It's certainly not true to my experience, though perhaps framing these things as a dichotomy is useful.

I have faith that all actions have significance. It is impossible to act without reason. Consequently, it is always possible to discover something of interest through action, through making. It might take a while to find the thing with sparks. The mind is big and complicated. The things we make are just as complicated. It's not possible for our conscious minds to be in control of all the meanings generated by what we make. Having faith that that is the case, art making is an opportunity to explore the nature of the mind. If you come at it from the other direction, insisting that it all makes sense, you miss an opportunity to really take advantage of the bigness of what we are.

10

2003
Sheetrock box, five plastic containers, papier-mâché, red plastic box, red rope, fabric, circle of pink carpet, plywood, red plastic vessels, red bath mat, coffee table, acrylic paint
71 × 45 × 80 in
180.3 × 114.3 × 203.2 cm

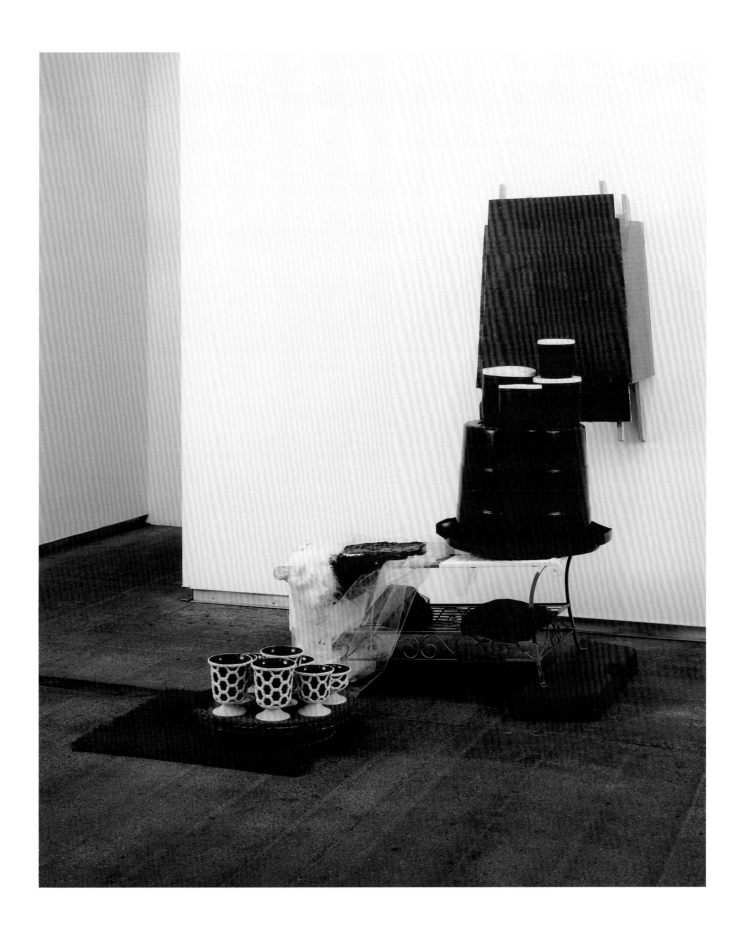

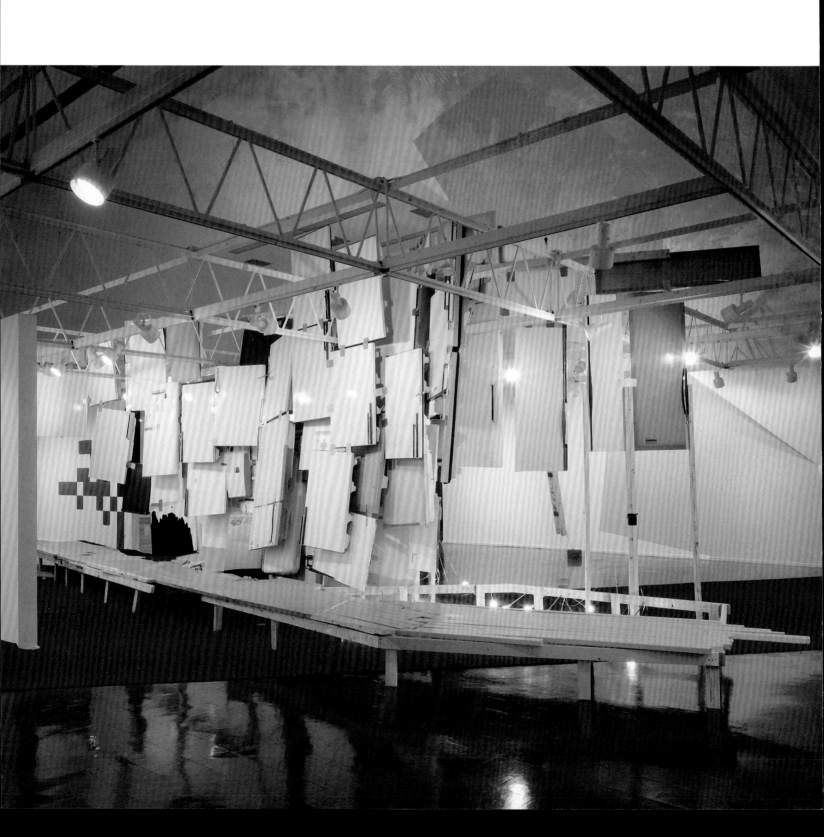

CIRCUITIO, MEMORY, AND THE MEDIEVAL MAPPING OF SPACE

WRITERS HAVE ANALYZED JESSICA STOCKHOLDER'S exploration and exploitation of boundaries from the perspective of literary and art theory, as well as philosophy and psychology/psychoanalysis.[1] No one has commented on the close relationship between her work and medieval modes of mapping. Just as Stockholder toys with narratives of space, mapping out visual puzzles by using familiar objects, color and word play, and covert pathways in her installations in ways that appear nonlinear and perhaps even nonsensical, people in the medieval period also resorted to the use of object, word, color, and trajectory in their legal inscription and description of physical space. In both instances conventions of literal mapping can only interfere with and obstruct what amounts to a subjective but entirely persuasive spatial narrative. Like medieval word maps and *mappae mundi*—respectively, mappings of territory using words instead of images and maps of the known world—Stockholder's work offers an alternative hermeneutics of the senses that is based in perambulation.

In another essay in this catalogue, Miwon Kwon uses Stockholder's work to rethink a particular passage in a famous essay by Rosalind Krauss that had been nagging at her consciously and unconsciously for years. Similarly, Stockholder's work has permitted me, a medieval historian interested in questions of colonization and changes in land use, to rethink basic assumptions about medieval mapping. Whereas medieval *mappae mundi* and charters demarcated and described space for individuals in a time when there was very little "real" mapping, Stockholder's work provokes audiences to reexamine space in a time when mapping has become so mundane as to be reflexive.

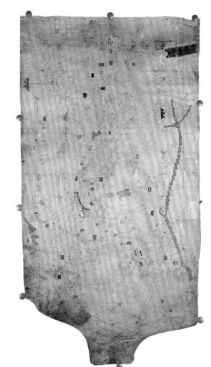

12

Portolan Map: Carte Pisane
Probably made in Genoa, Italy,
in the late thirteenth century,
this is the oldest example of a
portolan, or nautical chart based
on compass settings.
BN Res. Ge. B 1118
19.7 × 40.9 in
50 × 104 cm
Courtesy of the Bibliothèque
Nationale, Paris

Her work jars observers loose from their "MapQuest" mindset, provoking them to return to a subjectively determined trajectory that would have been very familiar to people in the medieval period.

The standard story about the history of cartography until quite recently posited that various sophisticated tools and means of measuring and representing territory in Roman times were obscured and then lost during the medieval period, only to resurface in much more sophisticated form with the emergence of a science of cartography during the European Renaissance.[2] This view, which presumes that medieval people did not need to, did not want to, and did not know how to map properly,

11

Skin Toned Garden Mapping, 1991
Installation, The Renaissance Society at the University of Chicago,
Chicago

is currently being revised by cartographers and historians alike. Evelyn Edson, among others, has wondered if medieval mapmakers perhaps had something else in mind other than to simply represent a known world in an objectively accurate fashion.[3] She notes *portolan* maps (sea charts) [Plate 12] surviving from the thirteenth century as isolated examples that conform to modern sensibilities of what a good map should look like: in other words, when medieval people needed to represent space literally, they did so.

In complete contrast, the *mappae mundi* [Plate 13], maps of the known world, are visually magnificent and messy narratives that organize physical geography in a didactic, Scripture-directed fashion. Geographical accuracy was subordinated to the message that the center of everything was Jerusalem, the navel of the world. The marginality of non-Christian territories was embodied in illustrations of the monstrosities that lay in wait, perhaps for the unwary pilgrim, from Amazons to marvelous foot-headed creatures (cephalopods). To further assist the spiritual journeys that these maps were intended to guide, written text was included outside the main body of the pictorial map, as instructive marginalia.[4] Like installation art, *mappae mundi* were not intended for easy transport but were unwieldy, semipermanent works, often intended for the hall of a monastery, and usually were meant to be viewed and studied by many. In addition to their function as symbols of the monastery's spiritual and material status, *mappae mundi* were mnemonic tools for imaginative travel by wishful pilgrims whose movements were, in fact, restricted, routinized, and closely scrutinized.

What modern observers have noted was lacking from *portolan* maps, *mappae mundi*, and other medieval map forms such as T-O maps and zonal maps[5] was any reference to latitude and longitude—ideas that seemed to have been either lost or unimportant to medieval mapmakers. For those who associate rationality with standardization, this absence of any attempt to organize space around an objective, orienting grid is perhaps the most damning evidence of the medieval world's loss of "real" representation.[6]

Between this imposed binary opposition of irrational *mappae mundi* and the more rational *portolan* charts was another very popular version of medieval mapping, the written charter.[7] Here, the question of the mapmakers'

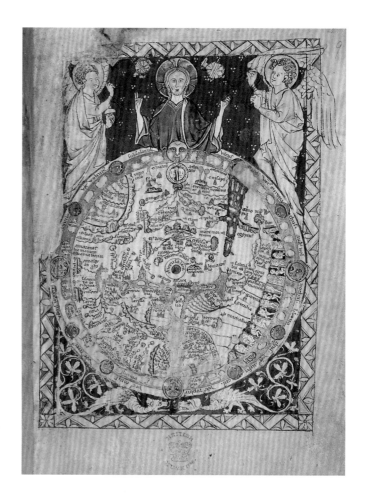

13

Psalter World Map, 1265
This map includes all the features of the great *mappae mundi* of the thirteenth century on a greatly reduced scale.
Bl. Add. MS 28681, fol. 9
3.5 in diameter
8.9 cm diameter
Courtesy of the British Library Board

intention is again critical. Charters included legal grants of property and property rights—they could range in size from small scraps of parchment to considerable tabletop proportions, and in prestige from hastily scribbled transfers of modest holdings to grants of entire cities and territories presented in formidable-looking documents made even more weighty by pendulous seals. With the rise of literacy, the increased production of texts, and the expansion of populations into less developed regions in the twelfth and thirteenth centuries, these charters of privilege proliferated, leaving us with a vast store of "imagined territory" that has been little understood as

a genre beyond its face value as a legal record. Stockholder's work, with its combination of sculptural, architectural, and textual features, provides a unique prism through which to reexamine medieval questions of spatial representation and imagined territories, liberating those questions from the burden of comparing what is "premodern" to what is "modern."

What the mostly anonymous medieval authors of charters shared with Stockholder is a desire to rearrange familiar landscapes by removing them in some way from their expected order, shifting the viewers' perspectives by reorienting their spatial assumptions, and sending them on what amounts to an ontological journey during which the observer redefines what is being observed. In thoroughly medieval fashion, Stockholder memorializes the viewers' experience through a succession of shocks—in her case through the pleasant if sometimes discomfiting aesthetic shock of light, color, and displacement. Absent from her work are the more extreme forms of medieval memorializing practice, which often included violent and/or sexual imagery as ways to imprint an image or act into individual and collective consciousness. Yet the immediacy and physicality of Stockholder's larger works draw comparison to the medieval practice of incorporating real violence into the task of memorialization. In the *circuitio*, the practice by which a lay or ecclesiastical lord legally confirmed his claim to a particular territory by riding its boundaries in a public display of authority, he sometimes concluded the act by striking a young male on the head. This blow served as a mnemonic for the *circuitio*, ensuring that whoever saw it would be sure to remember, thus confirming its legality for a still largely oral legal culture. Just as an image of an act of lurid violence, or the act itself, could serve to fix the legal enactment of territory in the minds of medieval witnesses, Stockholder's use of color and dissonance (things-out-of-place as well as found materials) emblazons her work on the minds of her audience: their memory of her installations is readily accessible via the jarring mnemonic devices of refrigerator doors hanging like slabs of Chicago beef[8] [Plate 11], vast granaries of bundled insulation[9] [Plate 14], and elegant chantilly lace draped next to cargo containers[10] [Plate 15].

But the best way to demonstrate that Stockholder's work should be examined from the standpoint of historical-legal-cartographic valence as well as from

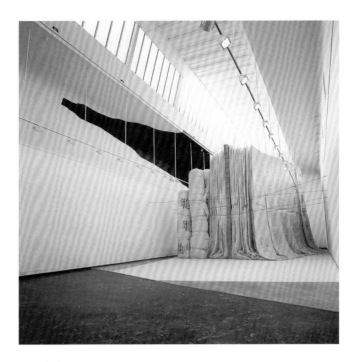

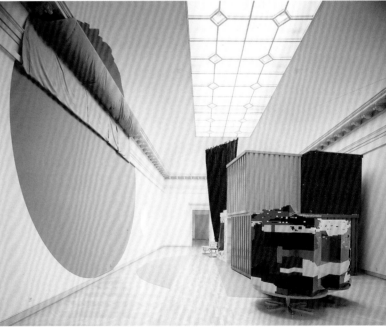

14

Slab of Skinned Water, Cubed Chicken & White Sauce, 1997
Installation, Kunstnernes Hus, Oslo

15

Vortex in the Play of Theatre with Real Passion: In Memory of Kay Stockholder, 2000
Collection Kunstmuseum St. Gallen, St. Gallen, Switzerland

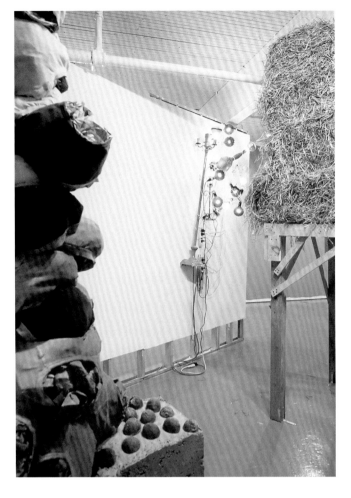

about to encounter a specific category of experience.[11] But whereas Stockholder attempts to destabilize or subvert that experience, the drawers of the charter wished to reassure the settlers that the charter was binding. The effect on both sets of viewers is to frame what lies inside within particular conventions.

Just as the charter's protocol eased viewers into the core document, the gallery entrance at the Dia Center pulled them into Stockholder's installation. In both cases, the creators relied on and framed the informal and perhaps inchoate knowledge and experience of their viewers within a highly formalized context. Stockholder introduces found objects of the most endearingly mundane type, arranging them in jarringly artificial patterns that impart to them monumental significance. Underwear stuffed with newspaper rises in an intimidating tower (*Indoor Lighting for My Father* [1988], Mercer Union, Toronto) [Plate 16]; thick yellow electrical cords spill outward like some sort of monstrous intestinal snarl (*Your Skin in this Weather Bourne Eye-Threads & Swollen Perfume*) and radiators huddle to form an ominously modernist military phalanx (*With Wanton Heed and Giddy Cunning Hedging Red and That's Not Funny* [1999], Center for Visual Arts, Cardiff, Wales) [Plate 18]. What she does with these assemblages is essentially to reevaluate the familiar landscape of domesticity, illuminating what is so mundane as to be nearly invisible and reassembling it with an aggressive intent (which I'm sure she'd deny) sufficient to strike even the jaundiced eye. One doesn't forget that Trajan's column of underwear or the irresistible pull of the electrical cords or the menace of the radiators. What we daily take for granted has been made visible and has been imprinted on our memories.

the contemporary artistic context is to emulate the ways that medieval charters and her installations operate subjectively—by walking through them.

Stockholder's installations, whether in a gallery or outdoors, share with charters a preliminary encounter between the viewer and a predetermined formal structure. Stockholder engages her audience as they move into her works from external and more public settings—an entryway to the gallery in the case of *Your Skin in this Weather Bourne Eye-Threads & Swollen Perfume* (1995) [Plate 17] at the Dia Center for the Arts, New York—just as those who drew up the Kulm charter granting urban privileges to thirteenth-century German settlers handled the transition of readers/hearers from the standard formal structures of the charter genre into the document itself. Both the gallery's carefully neutral entry—its propriety dislodged by Stockholder's placement of a discordant green lure—and the charter's formal attributes signaled to their respective audiences that they were

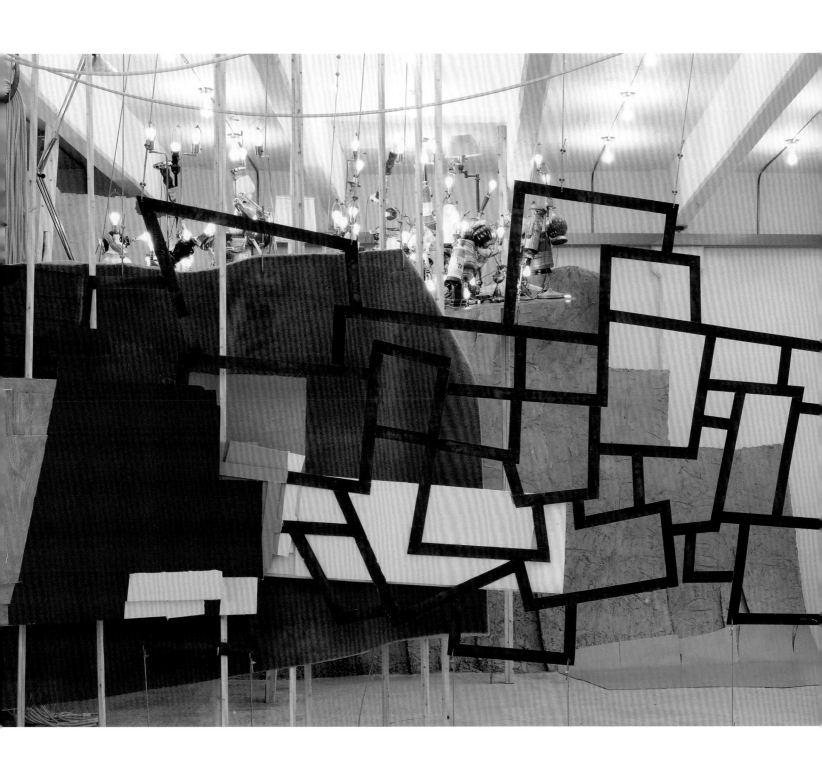

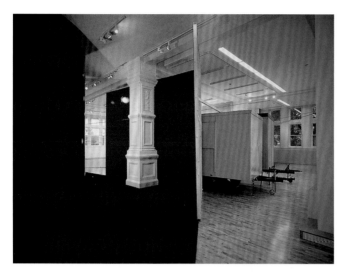

18

With Wanton Heed and Giddy Cunning Hedging Red and That's Not Funny, 1999
Installation, Center for Visual Arts, Cardiff, Wales

Like the medieval charter, Stockholder's work functions as an alternative inner map: the brilliant green path outside the Dia Center installation transgressed the boundary between formal and subjective experience, transporting travelers into a dynamic reassemblage of a once familiar museum landscape. The colorful disruption of the antiseptic entry disquieted patrons like a fissure in an otherwise immaculate surface, drawing them toward the orchestrated chaos within while at the same time activating their "fight or flight" impulses. What seemed like a safe and familiar passageway in fact was not. Stockholder's manipulation of the formal gallery entryway galvanized her audience into the heightened mode of sensibility required for them to actively engage in the installation inside. Here, everyday materials worked as comforting landmarks in an otherwise disquieting wilderness of brilliant color and strong light. Stockholder propelled her audience through her work with these kinds of oppositions, alternating corridors and thickets of activity with open plains where viewers could catch their breath, look back, and reconsider their position.

The Kulm charter was similarly structured.[12] The protocol set up a series of relationships between the local authorities who authored the charter and the settlers who were being granted specific rights within a certain territory. Just as the relationship between Stockholder and her audience is far from static, resembling a complex of possible paths rather than one firmly predetermined route, that between local lords and colonists was also dynamic and interactive, rather than a simple imposition of authority by one group onto another. Viewed as a text, like a charter, Stockholder's work forms a similar dialectic in that the author's initial inscription invites further glossing by her audience in an ongoing process of creation. Her installations have the very medieval characteristic of providing a point of departure for further comment, improvisation, and embellishment by viewers rather than dictating a firm and restricted program.

Considered as a map, Stockholder's work functions on the principles of a medieval street layout more than a modern grid. Negotiating narrow and irregular passageways, viewers sidle alongside barriers of unlikely material—walls of carpet, vaguely menacing electrical cords—to emerge in the equivalent of an open market square typical of public space in the thirteenth century.

There is no latitude nor longitude. Like a medieval town, however, this arrangement is chaotic only to the outsider, which her work never presumes or forces viewers to be. Rather her work presumes the development of an intimate knowledge by its viewers. Stockholder offers various routes through and around the assemblage of familiar landmarks instead of imposing one clear trajectory. The open areas function as sites from which to assess and perhaps renegotiate the passage just completed, providing a contemplative moment before moving on in the artistic process of experiencing the work.

Just as Stockholder's work encourages the development of a kind of local knowledge on the part of her audience, the Kulm charter also presumed an evolving local knowledge—a vernacular knowledge based on oral traditions and customary law—within the formal constraints of the legal text. Unlike the earlier version of the charter drawn up in 1233, the 1251 charter recognized that both the settlers and the lords of Kulm had now acquired an intimate topographical familiarity based on their eighteen years of peregrinations, a familiarity that was reflected in the vastly different quality of territorial description articulated in the two versions. What in 1233 was simply a lump sum of land and water granted to the townspeople (300 Flemish *mansi* of land, or about 12,600 acres, and one mile of river above and below the town) had become by the 1251 charter a rhapsodic word map of the territories granted, incorporating the vernacular names of villages, valleys, and lakes in a description that would have guided those hearing the text along a clear mental journey of the area delineated. In all other regards, the later charter restated the earlier, except here, where the charter's territorial description worked as an imagined version of the Silesian practice of the *ujazd*— a Slavic variation of the lord's *circuitio* described earlier in this essay.[13] The insertion of a word map imparted the later charter with a completely different and presumably more legally binding character.

What Stockholder's installations, like these examples of medieval mapping, provide is an opportunity to examine the very basic human urge to map from outside of the prevailing model that associates this proclivity with imperialism and the modern state.[14] The geographer Yi-Fu Tuan has linked this innate mapping instinct (shared by animals as well as humans) directly to language, something that we can see in the mapping action

of both Stockholder's work and numerous medieval examples. Stockholder's viewers move throughout her work, creating their own *circuitio/ujazd* within the confines that she has set. As they do, they are inscribing, through gesture and perception and agency, their own journeys within her *mappa mundi*. What Stockholder has done is to take a familiar lexicon (underwear, radiators, refrigerators, and so on) and organize it into a series of unfamiliar landmarks whose sequence and meaning are mutable and at least partially determined by the viewer. This openness includes the concept of "inside and outside"—trailers outside the formal boundaries of the work can be seen from inside; entryways that are supposed to buffer the institution from the art are slyly enlisted into the task of seducing viewers before they've crossed the threshold. Even her titles manifest her program of involution: *Slab of Skinned Water, Cubed Chicken & White Sauce* [Plate 14] becomes one more vivid assemblage of familiar terms, presented as a formal title, though it is far from a comforting descriptive summation. Perhaps it is this apparent absence of clarity—what seems to be a cryptic weirdness at first glance and begins to make sense only after strenuous involvement by the viewer—that most aligns Stockholder's work with medieval visual and textual aesthetics. Both rely on the workings of subjective knowledge to bring order to an otherwise discordant assemblage: the viewers create their paths even as they recognize them.

This nonimperialistic inconclusiveness to Stockholder's work alludes particularly to medieval traditions of mapping. Both defy certain conventions of rationality while at the same time invoking them, and both encourage audiences/witnesses/viewers to conceptualize public rituals as private journeys. What is highly unmodern about Stockholder's work is its emphatic regard for the centrality of human memory: both the drawers of the charter and Stockholder depend on a collective, perhaps even generational, familiarity with certain objects and landmarks as they structure new experiences—artistic in her case; legalistic and territorial in theirs. Memory is then further exploited as a means of preserving that new experience. The collective familiarity of medieval people with the landscape recounted in the Kulm charter and its specific detailing in its 1251 version made that later pronouncement all the more legally binding because of its references to the traditions of *circuitio/ujazd*. The mental journey invoked in the later charter made the grant more

real in the memories of the audience. Lump-sum grants of territory just didn't have the same legal purchase in a culture that was so pronouncedly visual in its organization of memory. Whereas medieval people relied heavily on the arts of memory in large part because alternative texts were relatively rare, contemporary people rely on memory as a refuge from the plethora of competing texts. The individual acts of *circuitio* that Stockholder makes possible with her work, and her unorthodox mnemonic devices, create a modern analogue to the combination of subjective experience and formal notations that characterize medieval mapping and memory. Once visited, her work becomes a private memory palace rather than a public territory—a monument accessible to its owner and continually reworked with every return visit. Like medieval maps, her work is unbounded by latitude or longitude, its meaning multivalent and never completed.

1. See Lynne Tillman, interview with Jessica Stockholder, in *Jessica Stockholder* (London: Phaidon Press Ltd., 1995), p. 26.

2. J. B. Harley and David Woodward, eds., *The History of Cartography, vol. 1, Cartography in Prehistoric, Ancient, and Medieval Europe and the Mediter-ranean* (Chicago: University of Chicago Press, 1987). This ongoing multi-author series is the place to begin any study of cartography.

3. Evelyn Edson, *Mapping Time and Space: How Medieval Mapmakers Viewed Their World* (London: The British Library, 1997), pp. 13–16.

4. The Ebsdorf Map and Hereford Mappa Mundi are two famous examples.

5. T-O (or O-T) maps organized the known world into a circle comprising three parts—Asia , Europe, and Africa—and were already an ancient form by the medieval period. Their crucifix layout was often applied to later medieval maps. Zonal maps organized the known world into frigid, temperate, and torrid layers, and were generally short on detail.

6. The literature on the topic of measurement, rationality, and state power is enormous, much of it inspired by the works of Max Weber. Witold Kula's *Measures and Men* is particularly relevant for his exploration of late medie-val and early modern standardization and its effects on class relations. Witold Kula, *Measures and Men,* translated by Richard Szreter (Princeton, N.J.: Princeton University Press, 1986).

7. Daniel Lord Smail has written a study of power struggles in late medie-val Marseille in which he uses municipal written records, including charters, to demonstrate the influence of what he calls "cartographic lexicons and grammars" on written documents. Daniel Lord Smail, *Imaginary Cartogra-phies: Possession and Identity in Late Medieval Marseille* (Ithaca, N.Y.: Cornell University Press, 1999).

8. *Skin Toned Garden Mapping* (1991), an installation exhibited at The Renaissance Society at the University of Chicago, Chicago.

9. *Slab of Skinned Water, Cubed Chicken & White Sauce* (1997), an installation exhibited at Kunstnernes Hus, Oslo.

10. *Vortex in the Play of Theatre with Real Passion: In Memory of Kay Stockholder* (2000), an exhibition at Kunstmuseum St. Gallen, St. Gallen, Switzerland.

11. Important charters such as the Kulm charter were identifiable by their physical size and general appearance as well as by their composition, which consisted of a protocol that included at the beginning the names and titles of those involved in the grant as well as a formal greeting. The text of the grant followed, and the document concluded with the names of witnesses.

12. Two versions of the Kulm charter were promulgated in the thirteenth century by local lords—the Teutonic Order of Knights—to encourage German settlers to come to the order's newly acquired region, now contained almost entirely in modern Poland. This deliberate colonization was part of a much larger movement often characterized as the *Drang nach Osten,* the first settlement of Slavic areas by Germans.

13. The *ujazd* is described by Richard Hoffmann in *Land, Liberties and Lordship in a Late Medieval Countryside* (Philadelphia: University of Pennsylvania Press, 1989), pp. 54–55.

14. James C. Scott, *Seeing Like a State: How Certain Schemes to Improve the Human Condition Have Failed* (New Haven, Conn.: Yale University Press, 1998).

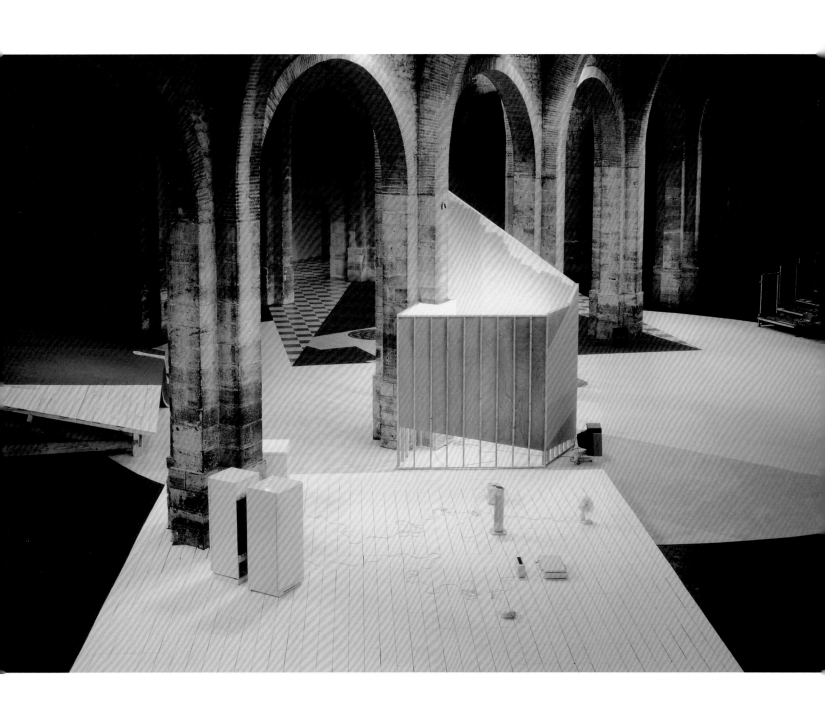

Miwon Kwon

PROMISCUITY OF SPACE: SOME THOUGHTS ON JESSICA STOCKHOLDER'S SCENOGRAPHIC COMPOSITIONS

JESSICA STOCKHOLDER'S INSTALLATIONS OFTEN appear messy and funky, almost out of control. Drawn from the stuff of hardware stores, secondhand furniture shops, garage sales, and basement storage rooms, her installations over the years have included ordinary things like oranges and lemons (plastic and organic), skeins of yarn, fabric, couches and chairs, carpets, refrigerator doors, mattresses, electric fans, lightbulbs, chests of drawers, cables, lamps, balloons, newspapers, blankets, birdcages, plastic storage bins, packing tape, linoleum tiles, electrical wiring, wire mesh, ribbon, shower curtains, twine, tables, spools of thread, bathtubs, washing machines, stoves, PVC piping, roofing paper, Christmas trees, clothing, tennis balls, nets, stuffed animals, cardboard, Sheetrock, old suitcases, lumber, kitchen sinks, and so on. This seemingly indiscriminate accumulation of "stuff stuck together"[1] is usually attached to, framed by, or supporting quasi-architectural constructions—platforms, ramps, walls, ledges, columns—which in turn play off of the existing architecture of the given exhibition space. Intersecting, overlaying, and juxtaposed throughout such a large-scaled assemblage is another layer of aesthetic information: bright patches or fields of paint (orange, aqua, yellow, red) that tend to disobey the contours of the accumulated objects as well as the shape and edges of the constructed or preexisting walls and floors. The sheer volume of disparate materials and visual cues in Stockholder's work has led various critics to describe her work as "things thrown eccentrically together," "orchestrated havoc," and a "cacophony of materials."[2] But all tend to agree that her seemingly anarchic installations achieve, in the end, a rather miraculous

formal resolution (as pleasing as a Matisse painting, for one critic). That is, Stockholder's talent in transforming diverse materials and visual languages into a coherent compositional whole has been duly recognized.

But to place central importance on the specificity of the installations' constituent parts (for a metaphorical reading) or the finesse with which the artist handles the heterogeneity of materials (for a technical appreciation) is to miss a key aspect of Stockholder's work. Certainly, the combining and modifying of the stuff of everyday life, literally including the kitchen sink, links Stockholder's work closely to the precedents of Allan Kaprow's and Robert Rauschenberg's assemblage aesthetic.[3] But in taking over entire rooms, hallways, and sequences of spaces as an arena within which, and in relation to which, to create assemblages in architectural proportions, Stockholder also figures as an inheritor of the prominent tendency toward spatialization in postwar art. (Different versions of this spatial ambition can be traced in a variety of practices, from Abstract Expressionist and Color Field painting to "flatbed" Combines, Minimalism and Process Art, Happenings, environments, installation art, and land art.) However, Stockholder's particular mode of constructing what I would call "scenographic counter-architecture" within the austere "real" architecture of art and museum galleries is not well accounted for in relation to, and in contradistinction with, other artistic endeavors that have also pushed toward broader spatial parameters or frames for the work's articulation. In confronting Stockholder's work, the inadequacies of various postwar art histories become all too apparent in this regard. Which reminds me . . .

19

TV Tipped Toe Nails & the Green Salami, 2003
Installation, capc Musée d'art contemporain de Bordeaux,
Bordeaux, France

A parenthetical remark toward the end of Rosalind Krauss's influential essay "Sculpture in the Expanded Field" (1979) has always troubled me. Every time I revisit the essay, I get stuck at the same point, at least momentarily, wondering how one might think through the assumptions and implications of the bracketed idea. Each time, I imagine that this thinking through would be important and worthwhile in opening up new ways of understanding certain aspects of post-1960s artistic developments. But this rupture in reading is always brief. I proceed to the end of the essay rather easily, bypassing the path of inquiry suggested by the seemingly casual parentheses. In doing so, I take my cue from the textual treatment of the remark itself, presented as an aside, almost a throwaway thought. I do not return to it. In fact, I forget it. That is, until the next time I come across it, and as if meeting a familiar bump in the road, I am reminded, there it is again, the unanswered question, waiting for a thorough unpacking.

The invitation to write about the work of Jessica Stockholder prompted me to decide that maybe it is finally time to attend to Krauss's parenthetical remark more seriously, if not to directly or fully answer it, then to reflect on it enough to get it off my back (for a while).[4] For some readers, putting Stockholder's colorful, decorative, theatrical, large-scale assemblage installations, comprising a motley selection of familiar stuff from daily life, into proximity with the stringent, anti-aesthetic vocabulary of some of the artists highlighted in "Sculpture in the Expanded Field" would seem an unproductive juxtaposition, a foolhardy art critical effort. But there is a specific way in which Stockholder's practice fails to fit into Krauss's schema that is of interest and significance. Why Stockholder's work should prompt me to rethink "Sculpture in the Expanded Field" will become clearer, I hope, as I proceed.

Krauss's essay lays out an impressive structuralist mapping of how the modernist category of sculpture— understood as autonomous, nomadic, self-referential, and universal—loses its centrality and grounding by the early 1970s. In the work of artists such as Carl Andre, Alice Aycock, Richard Long, Mary Miss, Robert Morris, and Robert Smithson, among others, Krauss sees sculpture reconnecting to its physical context, but not in order to return to the pre-modern logic of the monument— sculpture as place-bound commemoration. Krauss

instead argues that sculpture can now be understood as suspended between a set of oppositions, constituted as a double negativity: not landscape and not architecture. Sculpture is what is in the room that is not the room; it is what is in the landscape that is not the landscape. Unfolding the relations of opposition and negativity further, Krauss diagrams other alternative positions that define the expanded field of sculpture after Minimalism: marked sites (landscape/not-landscape), site constructions (landscape/architecture), and axiomatic structures (architecture/not-architecture). After leading the reader through her precise logical operation, she remarks as an aside (and here is the parenthetical statement that has been my stumbling block): "The postmodernist space of painting would obviously involve a similar expansion around a different set of terms from the pair *architecture/landscape*—a set that would probably turn on the opposition *uniqueness/reproducibility*."[5]

On the face of it, the remark does not seem all that remarkable. To propose uniqueness and reproducibility as opposing terms to map out painting's postmodern expansion seems reasonable enough. After all, techniques of mechanical reproduction—particularly photography—are unavoidable in thinking about, for instance, Andy Warhol's repetitive and serialized silkscreen paintings or Gerhard Richter's photo-realistic canvases and his citational paintings of various genres, including abstraction, still-life, portrait, and landscape. The complex tension between uniqueness (originality) and reproducibility (copies) is indeed a central problem for twentieth-century painting. But as one thinks about Krauss's statement, more questions creep to mind. For example, is she suggesting that the opposition of uniqueness/reproducibility is not equally relevant to sculpture?[6] Conversely, is the opposition of architecture/landscape not equally appropriate to painting, especially in the postwar period?

"Sculpture in the Expanded Field" is an essay that argues against the modernist necessity to maintain various mediums of art as separate and pure. Krauss explicitly counters the modernist critics of the 1970s: "What appears as eclectic from one point of view can be seen as rigorously logical from another. For, within the situation of postmodernism, practice is not defined in relation to a given medium—sculpture—but rather in relation to the logical operations on a set of cultural terms, for which

any medium—photography, books, lines on walls, mirrors, or sculpture itself—might be used."[7] Yet, does not Krauss's suggestion imply that a foundational, medium-specific opposition of cultural terms exists through which to map a particular medium's postmodern expansion—architecture and landscape for sculpture, uniqueness and reproducibility for painting? It might be commonsensical to situate sculpture in relation to spatial conditions defined by architecture and landscape, but is painting not also a spatial and spatializing practice?

The purpose of my posing these questions is not to undercut Krauss's claims or their impact, but to hint at the possibility of other art historical narratives, or relations between mediums, that might be occluded by the seemingly irrefutable, and thus powerfully seductive, logic of her argument. For instance, I wonder, perhaps illogically, about the possible relationship between Krauss's expanded field of sculpture and the "field" of Color Field painting. Further, what are the stories to be told about the link between the horizontal spatial drive evident in Jackson Pollock's allover drip paintings or Barnett Newman's wall-like, environment-making canvases and the spatial drive indicated in, for example, Dan Flavin's room-sized color light installations?[8] More generally, is there a convergence of New York School abstract painting and Minimalist and post-Minimalist sculpture, specifically around the issue of space, despite their supposed ideological opposition?[9]

It has become a commonplace in recent years to locate the origin of installation art (the category under which we can place Stockholder's art) to either Happenings or Minimalism—that is, to postwar neo-avant-garde performance or sculpture—insofar as both asserted temporality, bodily experience, and "real" space as integral aspects of aesthetic experience. This emphasis on "real" space, reflecting an interest in making art that calls attention to the actual material conditions of a room or that in itself becomes a spatial environment to move through or occupy, was a central point of debate among critics and artists of the generation following Abstract Expressionism. Broadly speaking, three different notions of space seem to have structured the discourse of art from this period. First is the residual notion of space as fictive, illusionistic, pictorial, representational, and depicted. This is the kind of mimetic space that Clement Greenberg wanted purged from painting as not only superfluous but also a betrayal of the essence of the medium. The second kind of space is abstract, ideal, and transcendent—beyond the visible and the material. This is the kind of sublime space that artists like Mark Rothko and Barnett Newman sought to achieve with their paintings, creating environments in their own right. Finally, there is the idea of space as literal, behavioral, phenomenological, "primary,"[10] social, and real—the space of lived experience. This is the kind of space that Minimalists like Morris and Richard Serra championed (with the support of critics like Krauss), which their famous detractor Michael Fried called "theatrical."[11]

What seems so distinctive about Stockholder's accomplishment in light of this discourse is how all three notions of space seem to come together and coexist in her installations. Without opting for one model of space over another, as her predecessors felt ideologically compelled to do, her work sustains a multiple spatiality, in which the viewer can simultaneously experience several different types of spaces. Moreover, the quality of these different types of spaces oscillates, so that what looks from one view to be a representational or pictorial space (distanced from and excluding the viewer) is in another instance actual, embodied space (immediate with and encompassing the viewer). Curator Lynne Cooke captures the complexity of such multiple spatial experiences in her assessment of Stockholder's tour de force installation *Your Skin in this Weather Bourne Eye-Threads & Swollen Perfume* [Plate 17], a 1995 work exhibited at the Dia Center for the Arts in New York City:

When the installation is first approached via the ramp, a view appears that is totally different in type from the one revealed later, when the panoramic scrutiny opens up from a single vantage point. In the former, the rectangular wooden jamb serves to hold in tension, in precarious and momentary equilibrium, various "events" that are experienced temporally—plummeting vectors, partially concealed volumes and planes, and occluded spaces. By contrast, from the synoptic perspective, the seemingly promiscuous miscellany arranges itself as if a series of overlapping flat planes, in a composition that is now implicitly rectilinear in format and that exists in a kind of suspended present: in short, into an image whose duration and form is quintessentially retinal.[12]

What Cooke is pointing out here is not simply that Stockholder's installation gives on to different views and impressions depending on the viewer's relative position. Rather, she is describing the ways in which the installation *inscribes* the viewer *into* different modalities of spatial perception: both an embodied experience that unfolds over time through the viewer's movement through the work and a pictorial coalescence that freezes the work into an "instantaneous" image, flattened out into a series of planes, squeezing out time, space, and the viewer's body (reduced, as Cooke notes, to the retinal).

Here, then, is art that proposes the possibility of positioning itself between the two-dimensional, pictorial flatness of painting and the three-dimensional spatiality and scale of architecture. The status of the installation itself shifts from picture to object to architectural construction, with the given architecture of the exhibition space functioning as an integral framing and compositional element throughout.[13] Furthermore, in embracing painting and architecture equally, Stockholder's work asserts (somewhat voraciously) a both/and attitude rather than one of either/or. This affirmative partaking of both categories (evident even in Stockholder's smaller furniture-scaled works, like the pieces from the 1988–92 *Kissing the Wall* series) confirms Cooke's observation that Stockholder's installations are antithetical to the formally reductive or deconstructive approaches to site-specific art, seen in the work of, for instance, Michael Asher (brought to architecture through Conceptual Art and institutional critique) or Richard Serra (arriving at

architecture through sculpture). Stockholder's exploration of the interface and reciprocity between painting and architecture, as Cooke has put it, also supports the heuristic notion of "painting's extended field"[14] as a potential counterpoint to Krauss's "sculpture in the expanded field."

The ongoing realization of the consistency *and* discrepancy that coexist in the exchange between visual recognition and bodily encounter—of colors, objects, structures, and spatial modalities—is the dramatic reward for viewers of Stockholder's stagings (who inevitably become the works' "actors"). Her installations are simultaneously abstract *and* literal, pictorial *and* material, representational *and* real, decorative *and* structural, and available for haptic *and* optic apperception. And these oppositions flip-flop throughout a viewer's experience of any one installation. What produces these unstable doublings, engendering what the artist describes as "a struggle between different ways of viewing contribut[ing] to the rise of a kind of blur, a confusion of boundary,"[15] is that no one element, be it an object, a color, or an architectural structure (thus, by extension, spatial modality), is allowed to maintain its integrity or to fully accommodate another element.

Stockholder's use of color is particularly exemplary in this regard. Just as it is impossible to find a stable, objective sense of spatial orientation to inside/outside or front/back in her work (these relations continuously alter depending on the movement of the viewer), the presence of color as a surface condition is often undercut by color as volume and vice versa. In the installation *House Beautiful* [Plate 20], for example, exhibited at Le Consortium in Dijon, France, in 1994, a squared stack of 100 skeins of red yarn (two rows are painted over in a lighter shade of pinkish orange) sits as an almost abstract cubic form on top of a piece of olive green carpet. Next to the pink/red cube of yarn stands a household fan painted green, blowing "green" air away from the yarn cube and into the underside of a large rug. The rug is one among many others that hang from the ceiling by braided steel cables. This particular rug is slightly twisted in relation to the planes of the floor, ceiling, and walls, revealing in its drooping heavy form its materiality, on the one hand, and a resistance to its own flat rectilinear shape, on the

20

House Beautiful, 1994
Collection Le Consortium, Dijon, France

other. Further, the rug's pattern is visible from the under-side through the semitransparent green paint (matching the color of the carpet on the floor) that almost covers the full spread of the rug.

Even within this small installational episode, we can inventory the double operation of color in Stockholder's art. On the one hand, color is applied to the underside of the rug (green) and to the double row of yarn (pink); on the other hand, it is a material condition of the olive green carpet on the floor and the skeins of red yarn. The proximity of these surface/material aspects throws into relief the ambiguity of color in a profound way. The green-colored fan, for instance, oscillates between being a fan that has been painted green and a fan that is green, which is to say the status of color as an abstract or sur-face entity, with a detached and independent relationship to the world of things, collides with color as a condition of things in themselves. This interest in the play between the materiality of color and the color of materials is cen-tral to Stockholder's artistic effort. As she admits in a 1995 statement: "Color drives me. I make art to play with color, to see it work. . . . [But] I experience color as sculp-tural, as something that collects onto things and takes up space, a physical event existing next to physical objects."[16]

★ ★ ★

It is impossible in the end to effectively convey in words the shifting play of perceptual experiences within Stock-holder's installations, involving as it does the unpredict-able movement of the viewers' eyes and bodies as they negotiate the works' open-ended sequences of exposed and intimate moments. These moments, created through a seemingly idiosyncratic and arbitrary overlaying of colors, familiar objects, and spatial conditions, reflect Stockholder's ambitious and sustained exploration of the convergence of collage, abstraction, and the readymade—the three key artistic innovations of the twentieth century. Positioned somewhere between paint-ing and architecture, or compositing the terms of each, Stockholder's work produces an "experience having to do with the difficulty of having things cohere, a lack of definition, or a possibility for expansion lurking in the background of everything we make."[17] Just as the artist seeks to upset her own clarity of vision to "make room for new thoughts,"[18] she offers the same to her audience.

1. The characterization is the artist's own. See Jessica Stockholder, quoted in "Lynne Tillman in Conversation with Jessica Stockholder," in *Jessica Stockholder* (London: Phaidon Press Ltd., 1995).

2. See reviews for the exhibition "Jessica Stockholder. Gorney Bravin + Lee" by Jonathan Goodman, *Sculpture* (September 2001): 77–78; Christopher Chambers, *Flash Art* (May/June 2001): 151; Barbara Pollack, *Art News* (Summer 2001): 174.

3. On this link between Stockholder's work and assemblage, see John Miller, "Formalism and Its Other," in *Jessica Stockholder* (Rotterdam: Witte de With Center for Contemporary Art, 1991), pp. 32–43.

4. This essay was originally commissioned by capc Musée d'art contempo-rain de Bordeaux in France for the exhibition catalogue of Stockholder's installation *TV Tipped Toe Nails & the Green Salami* (2003).

5. Rosalind Krauss, "Sculpture in the Expanded Field" (1979), in *The Original-ity of the Avant-Garde and Other Modernist Myths* (Cambridge, Mass.: MIT Press, 1985), p. 289.

6. Krauss herself acknowledges just a few sentences before the parentheti-cal remark that photography maintains a pervasive and integral presence within the practice of those artists forging sculpture in the expanded field. But nothing is made of this in relation to the uniqueness and reproducibility of sculpture.

7. Krauss, p. 288.

8. Michael Auping makes such connections between Color Field painting and some Minimalist and land art through the trope of the sublime in his essay "Beyond the Sublime," in *Abstract Expressionism: The Critical Developments,* ed. Michael Auping (New York: Harry N. Abrams, 1987), pp. 146–66.

9. While the issue of space is not central to his argument, Hal Foster has mapped the simultaneous continuity and break between Minimalism and New York School abstraction in his essay "The Crux of Minimalism," in *The Return of the Real* (Cambridge, Mass.: MIT Press, 1996), pp. 35–70.

10. The term is attributed to Richard Serra in Auping, "Beyond the Sublime," p. 155.

11. Michael Fried, "Art and Objecthood," *Artforum* (June 1967); reprinted in *Minimal Art: A Critical Anthology,* ed. Gregory Battock (New York: E. P. Dutton & Co., 1968), pp. 116–47.

12. Lynne Cooke, "Fabricating sight/site," in *Your Skin in this Weather Bourne Eye-Threads & Swollen Perfume* (New York: Dia Center for the Arts, 1995), p. 29.

13. John Miller has observed that in Stockholder's work, "gallery space serves as an expanded canvas, not as a minimalist derived 'theater,' with its affinities with the Debordian spectacle." But I wonder how distant these two uses of the gallery space really are. See Miller, p. 38.

14. Raphael Rubenstein, in his evaluation of Stockholder's work, borrows this idea from the title of a 1996 exhibition at the Stockholm Konsthall and the Rooseum Center for Contemporary Art in Malmö, "Painting—The Extended Field." See Raphael Rubenstein, "Abstraction Out of Bounds," *Art in America* (November 1997): 111.

15. Jessica Stockholder, artist statement originally published in *Turn of the Century Magazine* (New York) (Spring 1993). Quoted in *Jessica Stockholder* (London: Phaidon Press Ltd., 1995), p. 142.

16. Jessica Stockholder, "Shapes of Things to Come," interview by Raphael Rubenstein, *Art in America* (November 1995): 103.

17. Stockholder, "Lynne Tillman in Conversation with Jessica Stockholder," p. 41.

18. Stockholder, "Shapes of Things to Come," p. 103.

21

1988
Underwear, newspaper, glue, wood, Sheetrock, paint, lightbulb
54 × 54 × dimension variable in
137.2 × 137.2 × dimension variable cm
Collection Susan and Michael Hort, New York

1989
Wood, green lamps with red bulbs, paint, Sheetrock, small coffee table,
electrical wires, power bar
Dimensions variable
Collection Ruth Kaufmann, New York

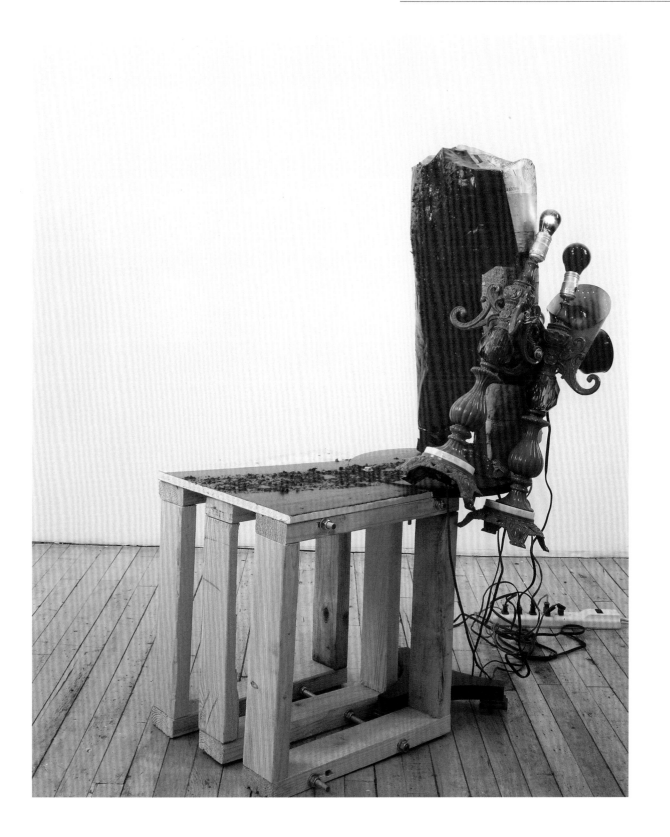

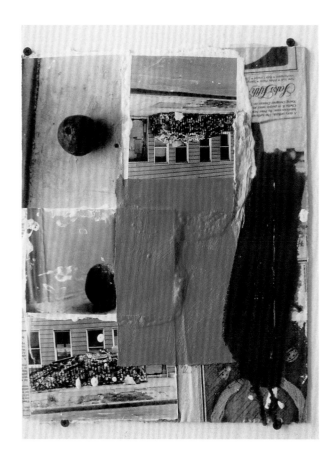

23

1989
Oil paint on a piece of board, plaster, photographs
12 × 14 in
30.5 × 35.6 cm
Collection Robin Resch, Princeton, New Jersey

1989
Acrylic and latex paint, car door, Sheetrock, cloth, oil, orange light, yellow
electrical cord, wood, hardware
54 in
137.2 cm
Collection Alice and Marvin Kosmin, New York

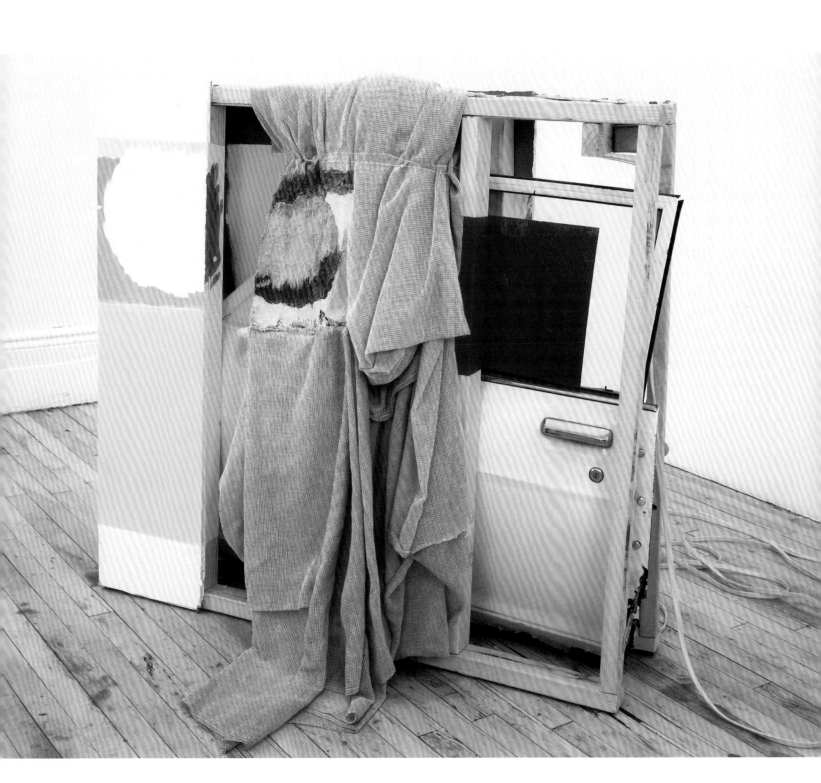

1990
Wool blanket, table, barbeque, oil and acrylic paint, fluorescent light,
night-light, two speaker boxes, wool, Styrofoam, newspaper, paper,
and glue
29 × 30 × 31 in
73.7 × 76.2 × 78.7 cm
Collection Jay Gorney, New York

26

Kissing the Wall #5 with Yellow, 1990
Metal strapping, spools of thread and wool, plastic cord, cloth, wood,
chair, oil and latex and acrylic paint, fluorescent light, paper, glue
30 × 36 × 54 in
76.2 × 91.4 × 137.2 cm
Collection Carol and Arthur Goldberg, New York

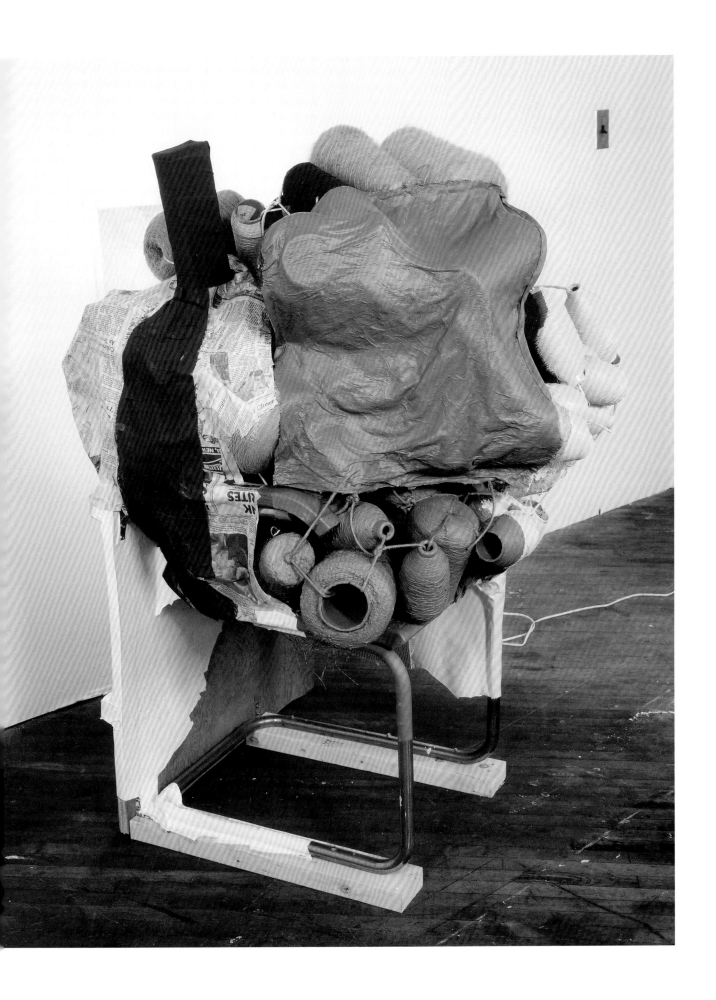

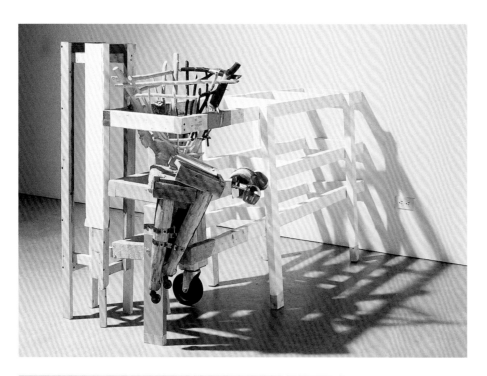

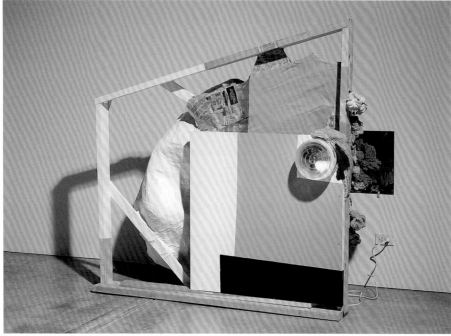

27

1990
Acrylic and oil paint, wood, wool, lights without bulbs, stool made of branches,
wheels, papier-mâché, duct tape, cloth
46 × 78 × 32 in
116.8 × 198.1 × 81.3 cm

28

1990
Wood, plastic, cloth flowers, lights in fixture (one red and one white), enamel,
latex, acrylic and oil paints, mirror, plaster, papier-mâché, cloth
63 × 70 × 34 in
160.6 × 177.8 × 86.4 cm
Collection Nancy and Joel Portnoy, New York

1991
Wood, magazine rack, papier-mâché, luggage, wheels, light fixture, mirror, cloth,
metal lath, wire, electrical wire
58 × 24 × 25 in
147.3 × 61 × 63.5 cm
Collection Eileen and Richard Ekstract, Sagaponack, New York

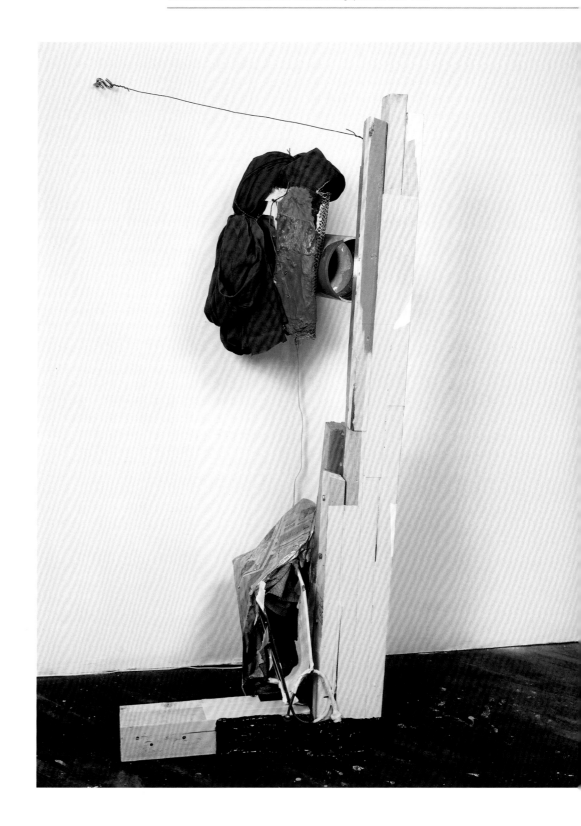

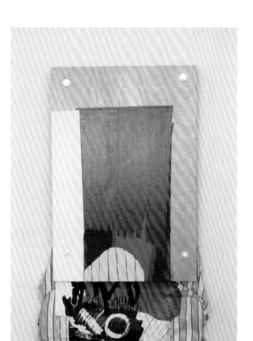

30

1991
Paint, plywood, cloth, paper, litho print on paper, hardware
32 × 17 in
81.3 × 43.2 cm

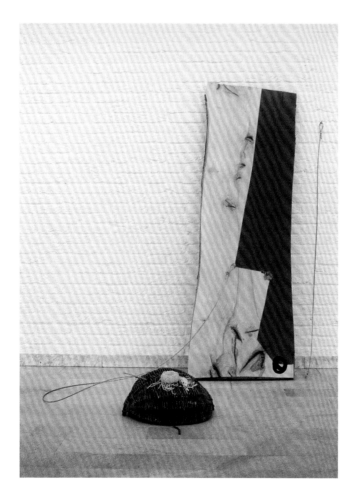

31

Lack, 1992
Westphalian basket, linen yarn, acrylic paint, metal cable,
section of tree
64 × 66 × 72 in
162.6 × 167.6 × 182.9 cm
Collection of the artist

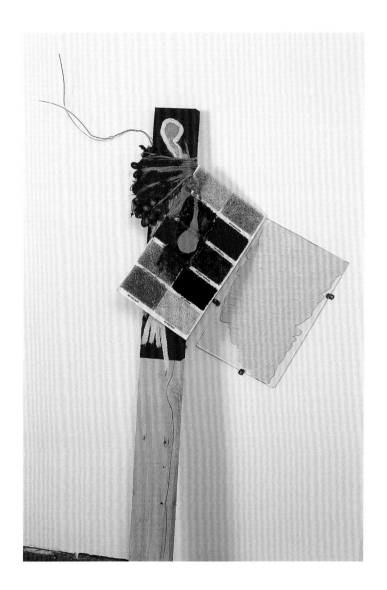

32

1993
Wood, glass, acrylic and oil paint, carpet sample board, plastic fruit, string, wire
47 × 30 × 11 in
119.4 × 76.2 × 27.9 cm
Courtesy Works On Paper, Inc., Los Angeles

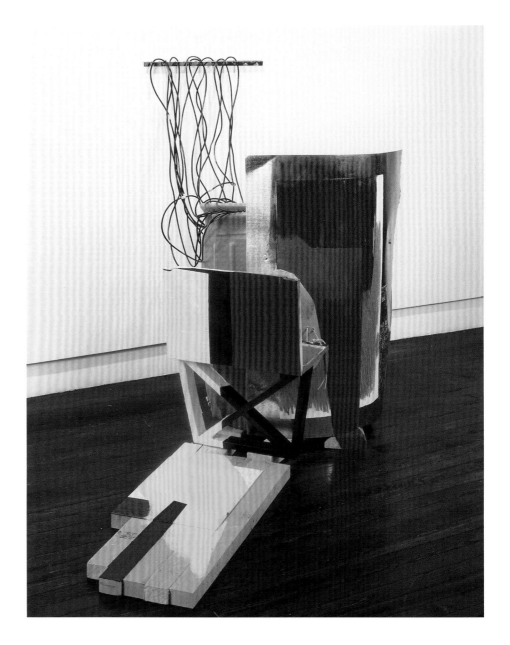

33

1993
Orange garbage pail, galvanized sheet metal, bolts, string, wooden furniture, wood, paper, oil pastel, oil and acrylic paint, linoleum tile, electrical wires, hinge
60 × 62 × 38 in
152.4 × 157.5 × 96.5 cm
Collection Weatherspoon Art Museum, The University of North Carolina at Greensboro, Museum Purchase with funds from the Judy Proctor Acquisitions Endowment, 2002

34

1993
Plastic sink, toolbox, aluminum tubing, wood, wire, acrylic yarn, hardware, green light and light fixture, acrylic and oil paint
72 × 38 × dimension variable in
182.9 × 96.5 × dimension variable cm
Private Collection, New York

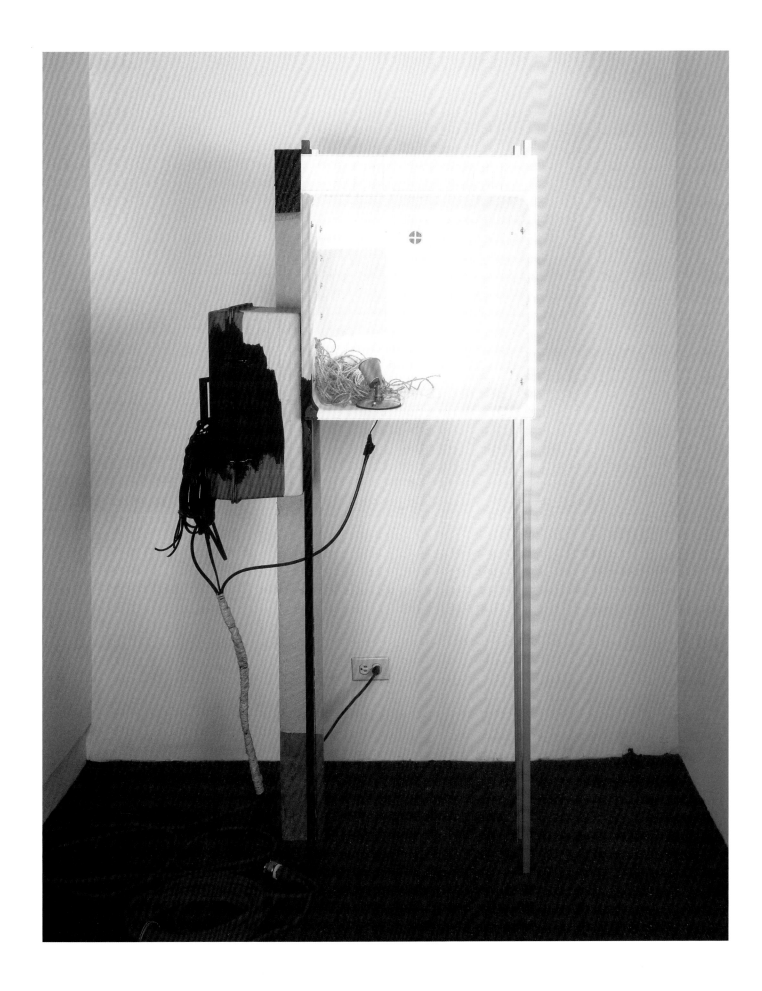

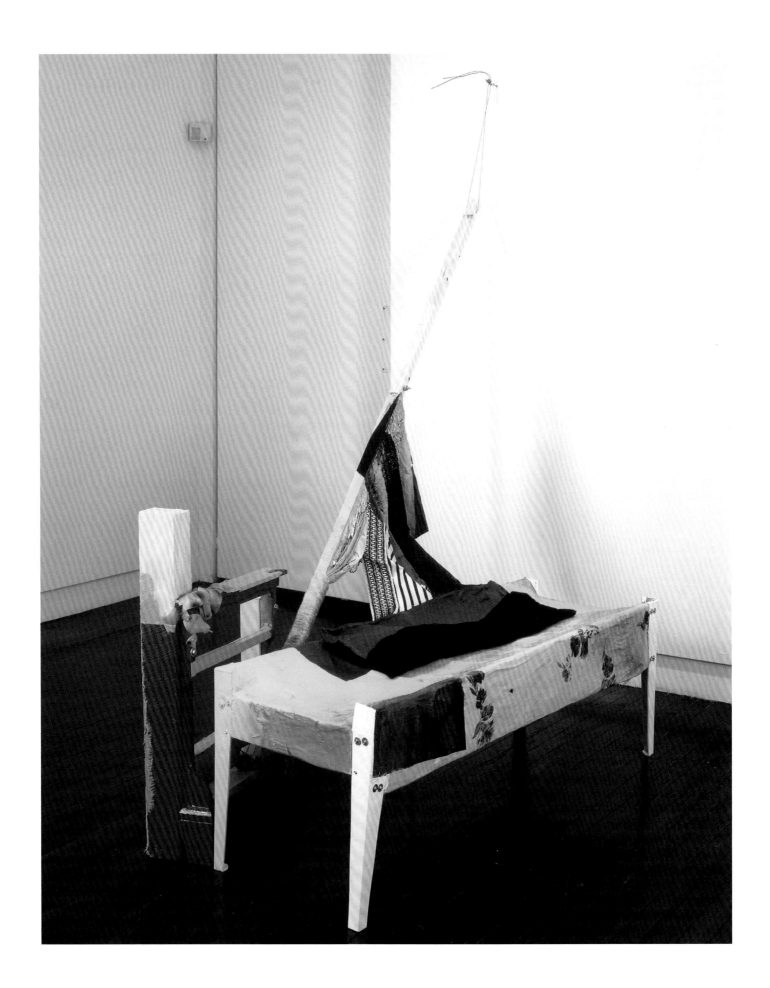

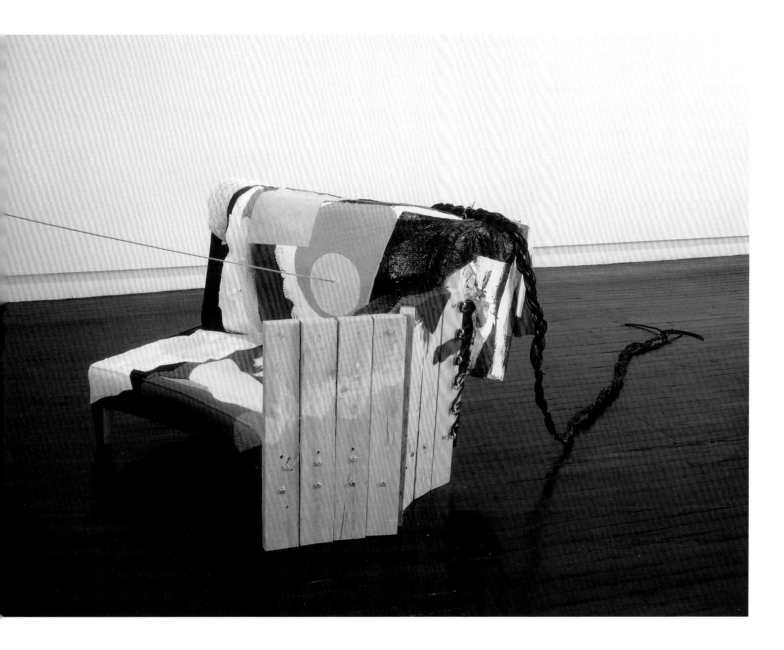

35

1994
Plastic sink legs, clothing, trimming, string, yarn, wood, hardware, piece of
furniture, papier-mâché, plaster, wallpaper paste, glue, acrylic and oil paint,
cable, silicone and latex caulking, plastic fruit
82 × 50 × 93 in
208.3 × 127 × 236.2 cm
Collection The Corcoran Gallery of Art, Washington, D.C.
Gift of the Women's Committee of the Corcoran Gallery of Art

36

1994
Pink couch, oil and acrylic paint, wood, hardware, electrical wiring, papier-mâché,
plastic, twine, clothing, string, nail
180 × 61 × 47 in
457.2 × 154.9 × 119.4 cm
Collection Eileen and Michael Cohen, New York

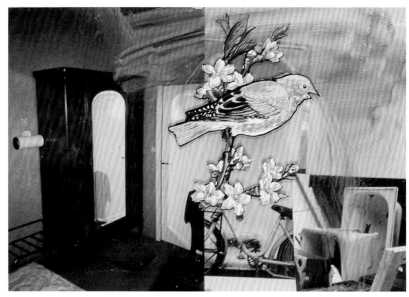

37

1994
Oil and acrylic paint, glass, plastic lid, yarn, silicone caulking
18 × 12 × 4 in
45.7 × 30.5 × 10.2 cm
Collection John Robertshaw, New York

38

1994
Oil paint, photographs, paper, decal on glass clip frame
5 × 7 in
12.7 × 17.8 cm

39

1995
Wicker chair, plastic tub, light fixture with bulb, synthetic polymer, oil paint,
plastic, fabric, concrete, resin, wood, wheels, acrylic yarn, glass and cookie
in resin
71.5 × 63 × 50 in
181.6 × 160 × 127 cm
Collection Whitney Museum of American Art, New York: gift of the Jack E.
Chachkes Estate, by exchange, and purchase with funds from the Peter Norton
Family Foundation and Linda and Ronald F. Daitz

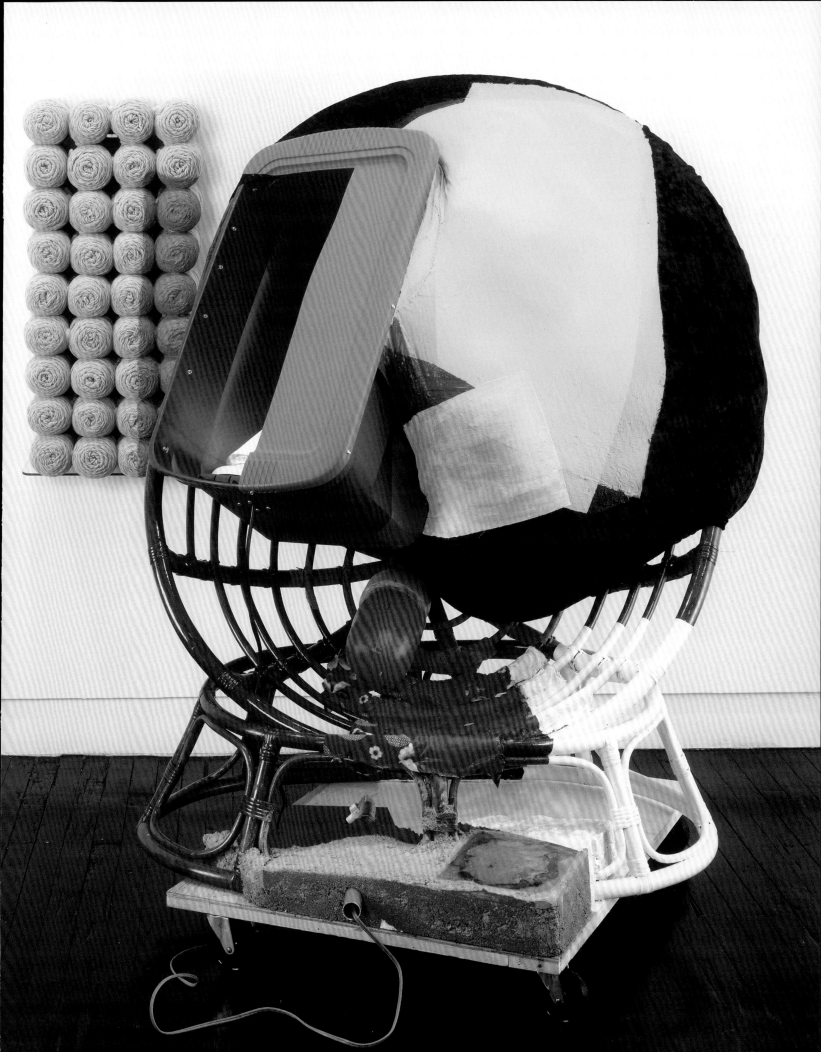

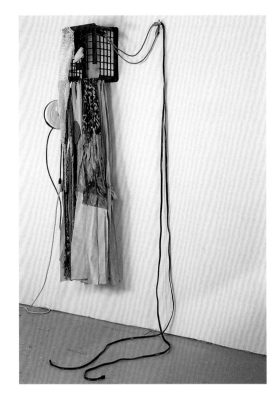

40

1995
Purple plastic stacking crate, two pipe warming wires, extension cords and cord winder, crocheted yarn, fabric, plastic, acrylic paint, hardware
94.5 × 46 × 48 in
240 × 116.8 × 121.9 cm
Collection Barbara and Thomas Ruben, Chicago

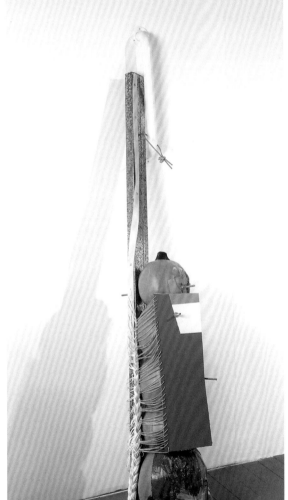

41

1996
Metal studs, white handle, rubber molding, plastic pumpkins, plastic, string, oil paint, cable, hardware
71.3 × 25 × 22 in
181 × 63.5 × 55.9 cm
Courtesy Gorney Bravin + Lee, New York

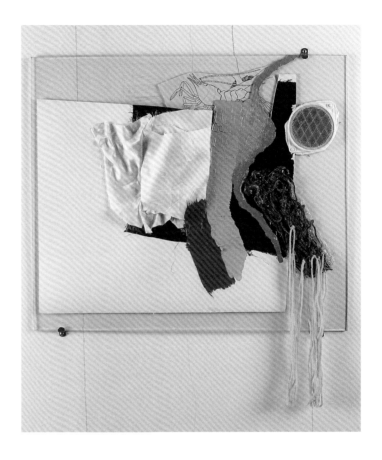

42

1996
Acrylic and oil paint, glass, fabric, drawing of lobster, reflector, silicone caulking,
Safe-T contact cement, yarn
19 × 22 × 25 in
48.3 × 55.9 × 63.5 cm

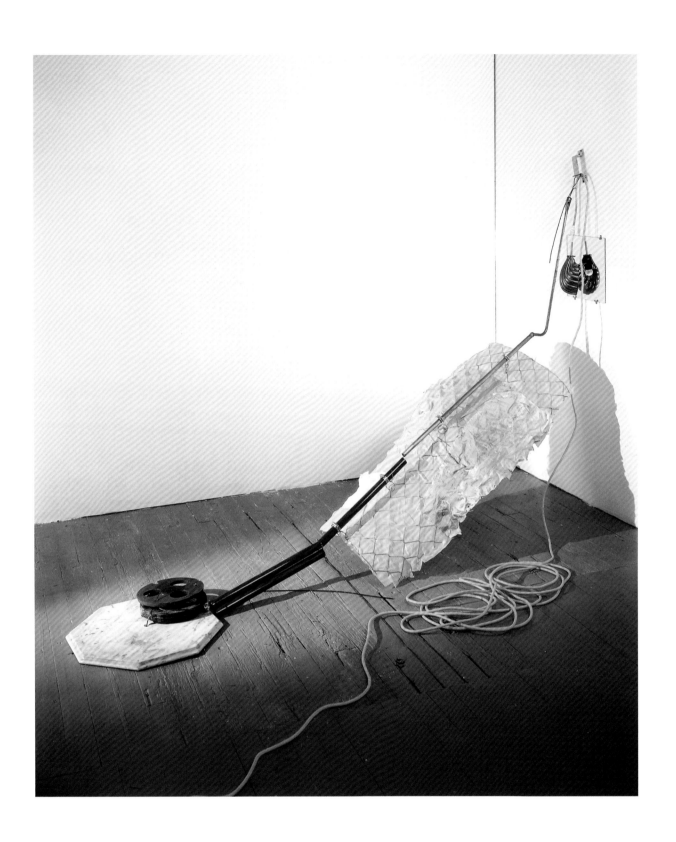

43

1996
Lamp parts, blue bulb, yellow cord, hardware, mirror, wire mesh, fabric, acrylic paint
68.3 × 24 × 97 in
173.4 × 61 × 246.4 cm
Collection Carol and David Appel, Toronto

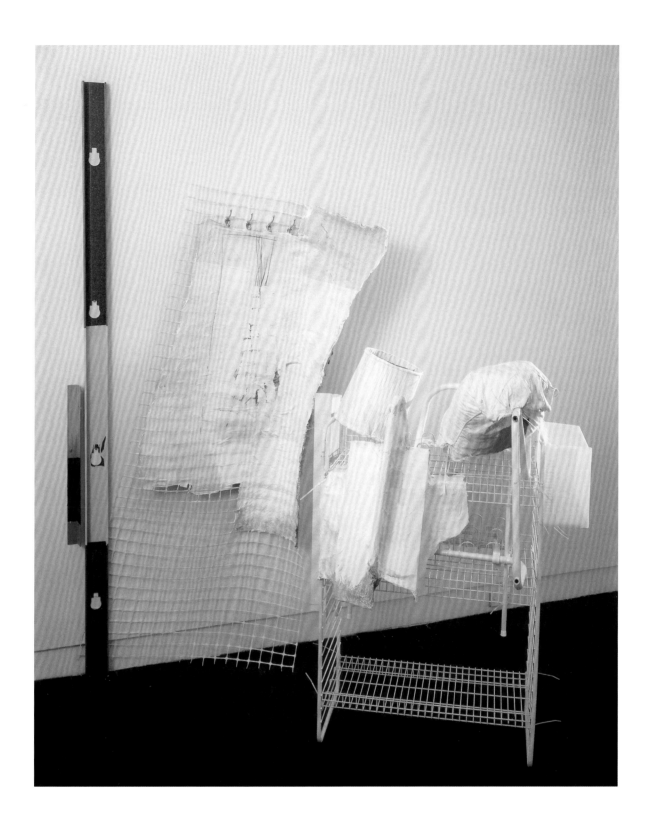

44

1996
Metal stud, angle iron, plastic mesh, paper with plaster and Celluclay, lamp
shade, Styrofoam, pillow, plastic and metal furniture, acrylic paint, newspaper,
electrical cable ties, four coat hooks
96 × 55 × 63 in
243.8 × 139.7 × 160 cm
Collection Susan and Michael Hort, New York

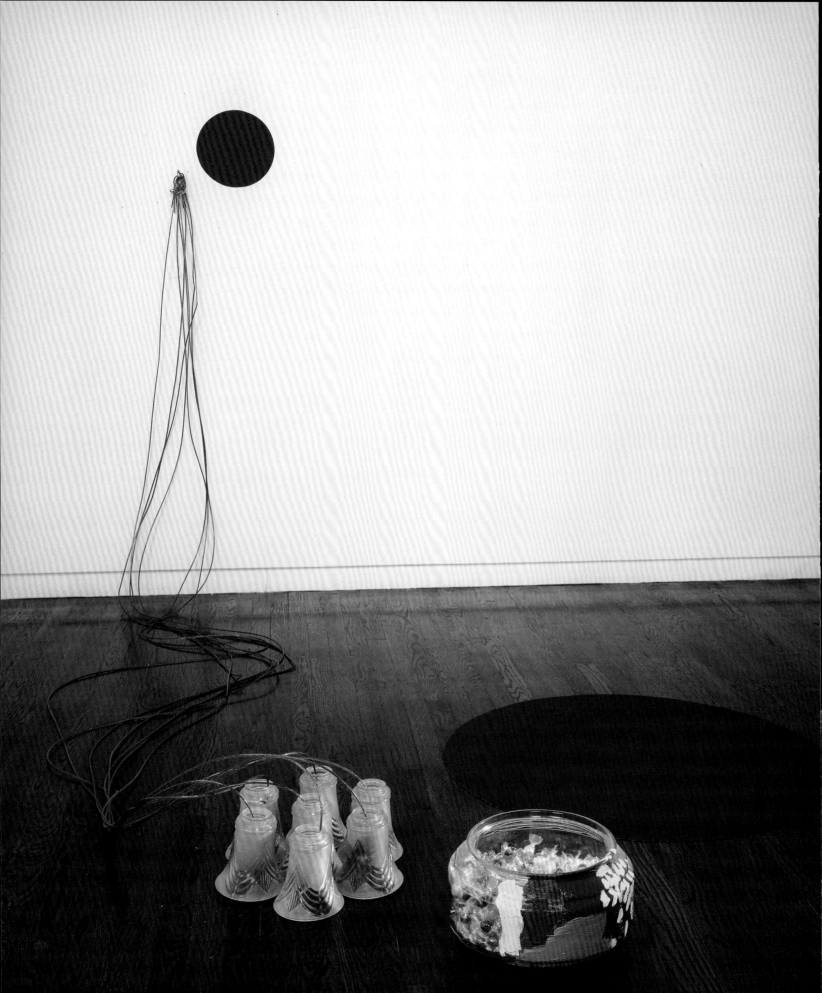

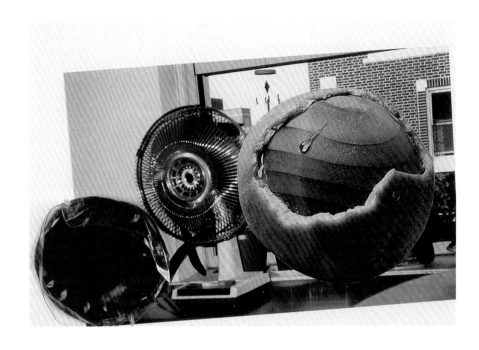

45

1996
Fish bowl, candles, glass light shades, plastic fruit, clothesline wire, hardware,
rubber mat, acrylic and oil paint
64 × 120 × 62 in
162.6 × 304.8 × 157.5 cm

46

1998
Color photo, magazine cutout, plastic, silicone caulking on glass clip frame
5 × 7 in
12.7 × 17.8 cm
Courtesy Gorney Bravin + Lee, New York

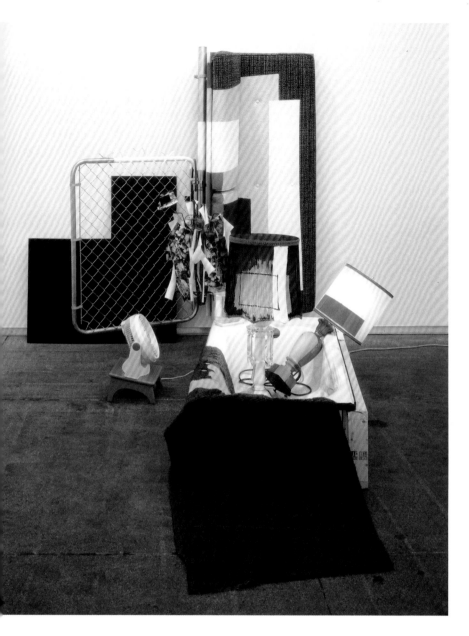

2000
Couch, photos, metal gate, plywood, two lamps, bathtub, fish tank, fan, stool, embroidery thread, fake fur, extension cord, metal stand, acrylic paint, metal bracket
82.5 × 84 × 128 in
209.6 × 213.4 × 325.1 cm
Collection Martin Z. Margulies, Miami

48

2001
Molding, papier-mâché over Styrofoam, acrylic and oil paint, aluminum/tar flashing, plastic containers, nylon webbing, aircraft cable, beads, two baskets
81 × 4 × 39 in
205.7 × 10.2 × 99.1 cm

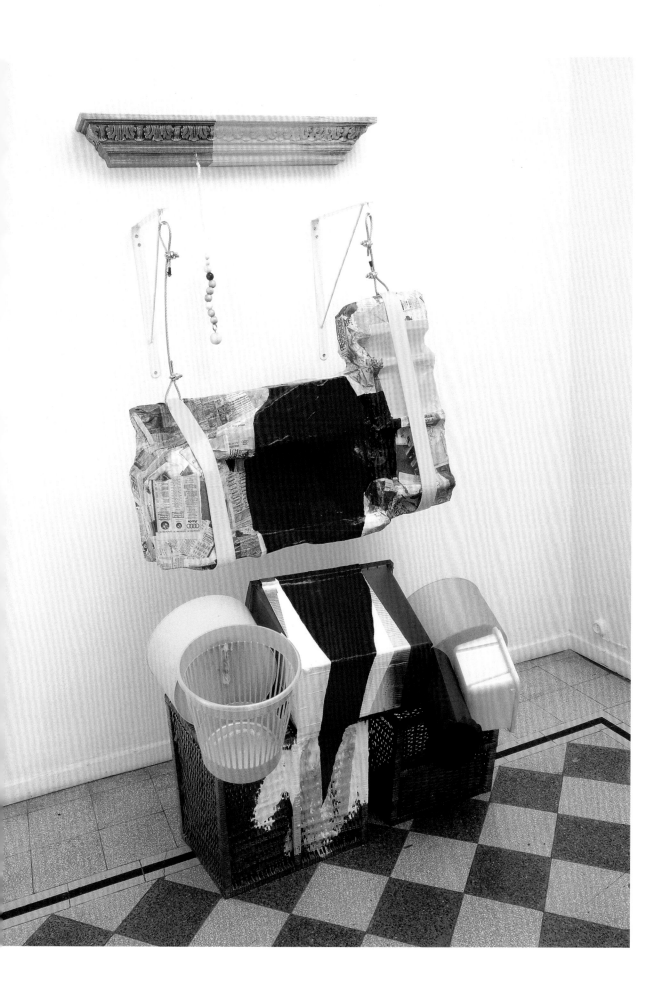

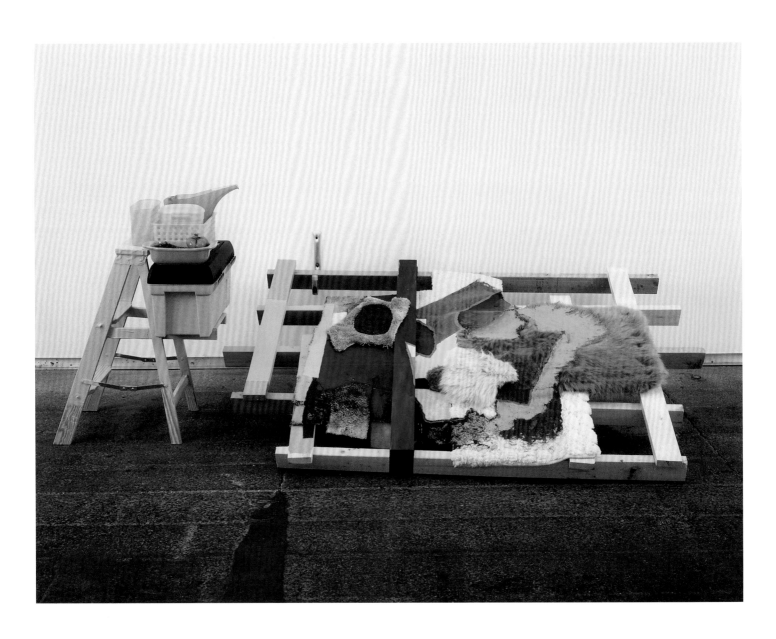

49

2002
Lumber, carpet, fake fur, ladder, plastic toolbox, plastic and ceramic
knickknacks, acrylic paint, silicone caulking, wall hook
39 × 105 × 59 in
99.1 × 266.7 × 149.9 cm
Courtesy Gorney Bravin + Lee, New York

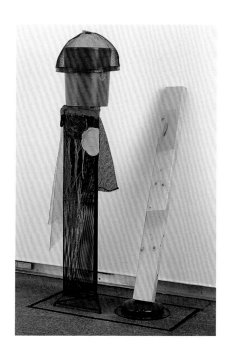

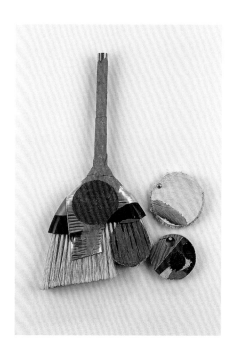

50

2003
Orange mesh cheese cover, plastic containers, metal mesh structure, red metal circle, 2 × 4 piece of wood, fabric, embroidery thread, fake fur, acrylic paint, black tape
46.5 × 26.5 × 19 in
118.1 × 67.3 × 48.3 cm

51

2003
Broom head, carpet, wood, aluminum/tar flashing, acrylic and oil paint
19 × 14 × 2 in
48.3 × 35.6 × 5.1 cm
Collection Randi and Eric Sellinger, New Jersey

2003
Carpet, metal coffee table, four butterfly lamps, chandelier,
various green plastic things, aluminum/tar flashing, oil and
acrylic paint, green extension cord
56 × 64 × 45 in
142.2 × 162.6 × 114.3 cm

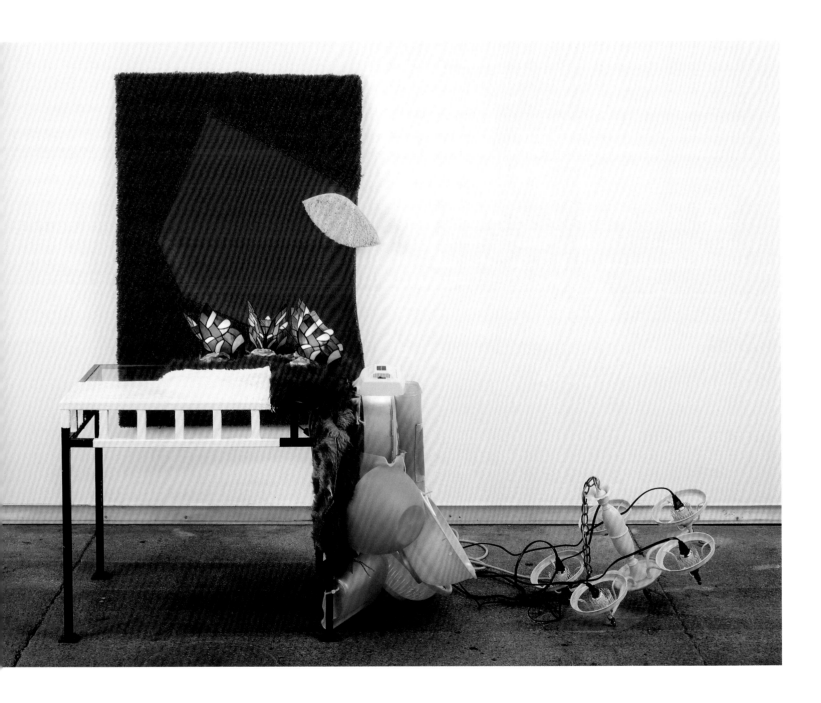

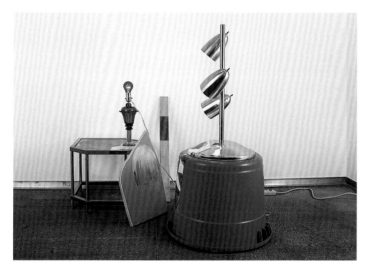

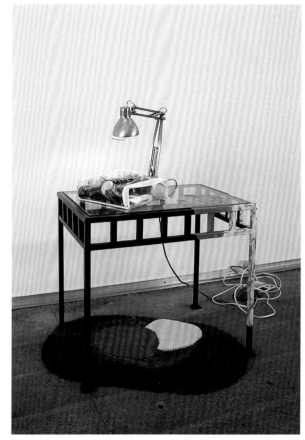

53

2003
Blue glass lamp, blue plastic bin, small gold coffee table with glass top,
plywood, silver lamp, aluminum/tar flashing, acrylic paint, fake fur
45.5 × 46 × 36 in
115.6 × 116.8 × 91.4 cm

54

2003
Plastic bag of plastic fruit, metal lamp, carpet, orange extension cord, acrylic
and oil paint, table
38 × 34 × 37 in
96.5 × 86.4 × 94 cm

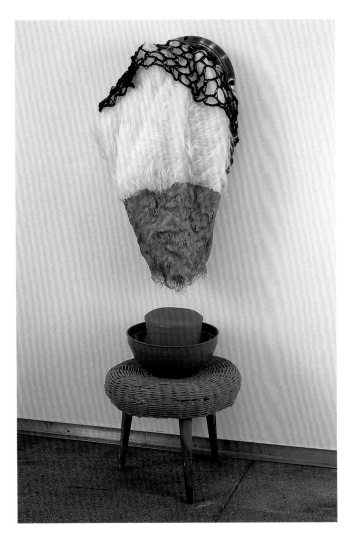 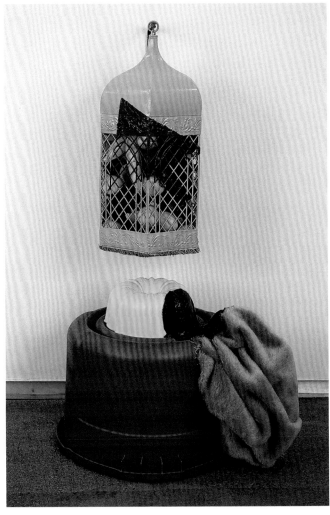

55

2003
Fan collar, white fake fur, fabric, crocheted acrylic yarn, blue plastic
containers, wicker stool
155 × 20 × 17.5 in
393.7 × 50.8 × 44.5 cm

56

2003
Birdcage, metal bracket, pink plastic tub, yellow plastic cake form,
fake fur, aluminum/tar flashing, thread, carpet, oil and acrylic paint
46 × 28 × 26 in
116.8 × 71.1 × 66 cm
Collection Eileen and Richard Ekstract, Sagaponack, New York

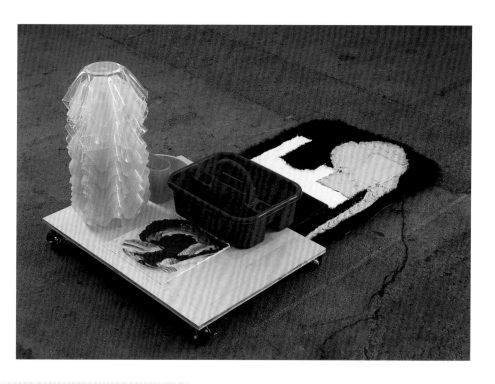

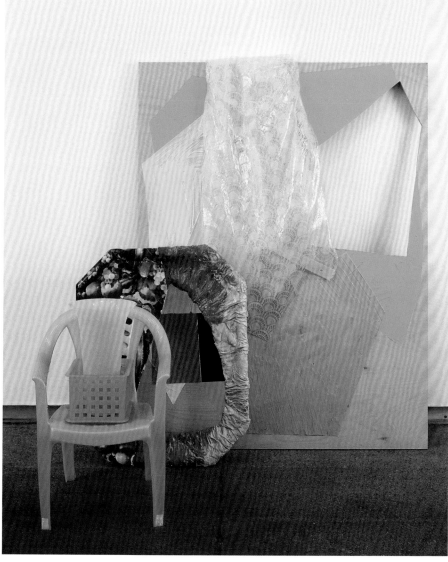

57

2003
Plywood with wheels, stack of seventeen green and clear
plastic bowls, four other plastic parts, rug, acrylic paint
61 × 35 × 27 in
154.9 × 88.9 × 68.6 cm

58

2003
Plywood, shower curtain, plastic tray, papier-mâché, plastic,
plastic child's chair, three plastic containers
15 × 50 × 32 in
38.1 × 127 × 81.3 cm

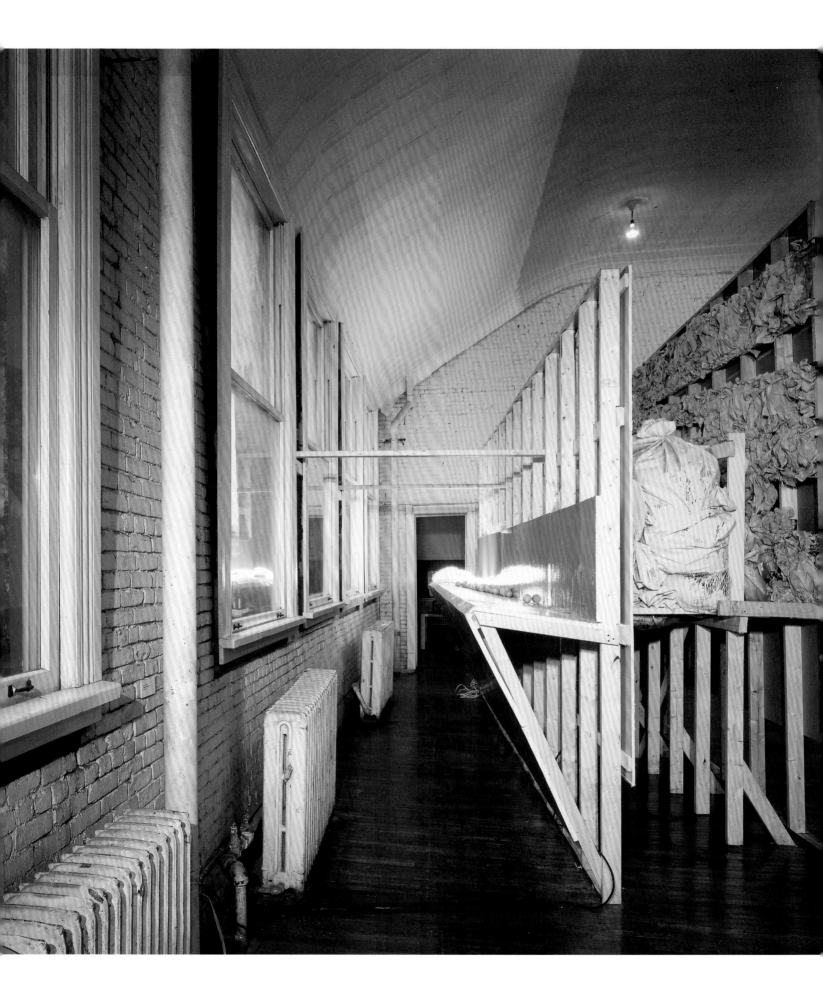

ANNOTATED CHRONOLOGY

I am always concerned with the complexity of boundaries, where one thing begins and another ends, where inside becomes out, where art meets life, the relation of back to front, fiction to reality, surface to structure.

Jessica Stockholder[1]

This chronology includes selected events and significant works/projects, accompanied by texts by and about Jessica Stockholder. For exhibitions and publications by year, please refer to "Selected Exhibitions and Publications, 1982–2003" in this catalogue. For a more traditional chronology of the artist's life to 1995, see Barry Schwabsky, Lynne Tillman, and Lynne Cook, *Jessica Stockholder* (London: Phaidon Press Ltd., 1995), pp. 150–58.

1959	Born in Seattle to English literature scholars, Professors Fred and Kay Stockholder.
1960	Moves with family to Vancouver, British Columbia, where her parents continue academic careers, remaining in Vancouver as transplanted New Yorkers.
	Stockholder still maintains a dual American-Canadian citizenship. The Vancouver landscape will remain a lifelong influence on her art.
1963–65	Lives with family in Ghana; travels to European museums.
1960s	On making paintings as a child: "It was always a frustrating experience. I felt that I lacked facility, that I was inept."[2]
1969	Attends her first poetry reading.
1973	When she is fourteen, her parents divorce.
	Father arranges for her to take drawing lessons from Mowry Baden (American, b. 1936). Baden, who expresses disdain for what he calls the "stand-off-and-look-at-it" attitude, makes sculptural pieces that assume the viewer is a moving participant.

1970s	First sees work by Jackson Pollock.
	Later Stockholder will express her appreciation for how Pollock's allover painting turns the picture plane into a dynamic stage while it mixes the material (paint, sand, bits of paper) with the timeless.
1977–80	Studies at University of British Columbia in Vancouver.
1978	Attends program at Camden School of Art in London.
	Makes paintings in the manner of Larry Poons and Jim Dine.
1980–82	Transfers to University of Victoria, British Columbia, and continues to work with Baden, crediting him with her acute attention to object-viewer dynamics.
	Awarded BFA from University of Victoria.
1983	Creates *Installation in My Father's Backyard* [Plate 2], in Vancouver. "I asked my father if I could make this work in his backyard. He said 'no.' I made it anyway and he was very proud! This work took the backyard as its frame—not unlike using a room as a frame. The grass in the backyard was rectangular and flat like the plane of a canvas designed by someone else."[3]

Like *Installation in My Father's Backyard*, virtually all of Stockholder's site-specific work is dismantled once the exhibition ends, existing thereafter only in photographs. Such transitory specificity is crucial to her installations. But the notion of ephemerality also courses through her smaller studio works.[4]

Making a Clean Edge, 1989
Installation, P.S.1 Contemporary Art Center, Long Island City, New York

1983–84 Studies painting at Yale University, New Haven, Connecticut. *"When I was a student, Abstract Expressionism was taboo, and it still is, even today."*

1984 Studies sculpture at Yale University. *"I didn't stop making paintings and start making sculpture. I still make paintings, only they are also sculpture."*[5] Studies with David von Schlegell, Ursula von Rydingsvard, Judy Pfaff, Jake Berthot, George Trakas, and Nigel Rolfe.

1985 Awarded MFA, Yale University.

With Isamu Noguchi, installs permanent outdoor installation at Beinecke Plaza, Yale University.

Awarded first of several Canada Council for the Arts grants (will later receive major Canada Council awards in 1987, 1988, 1992, 1993, 1994, and 1996).

Moves to Brooklyn, New York, residing there until 1999.

1987 Kay Stockholder publishes *Dream Works: Lovers and Families in Shakespeare's Plays* (Toronto: University of Toronto Press, 1987).

Installs *It's not over 'til the fat lady sings* [Plate 60] at Contemporary Art Gallery, Vancouver.

By 1987 Stockholder had made several significant site-specific works; this was the first made in Vancouver in years. Her grandmother suggested the title. *It's not over 'til the fat lady sings* contained many elements characteristic of Stockholder's practice: furniture, newspaper, carpets, clothing, plaster, plywood, 2 × 4 lumber, and metal building materials. It also revealed her distinctive use of color: bright, solid swaths appearing at various places, sometimes partially covering furniture, walls, or floors.

Her artist's statement addresses a major motif in her work: *"Clothes act as skins over our skins; carpets act as skins on our floors; walls are the skins of our rooms; we see the outside skin of the furniture; and the paint acts like a skin on all of these skins, including that of the gallery wall. All of these skins are intermingled and woven together."*[6]

As this work demonstrated, her art reacts against the "white cube" of the gallery, disrupting and subverting the space in various ways. At the same time, she relies on the rarefied world of museums and galleries to make the work exist as an "art object" situated within a history of art. Both large installations and smaller studio works draw a degree of energy from this seemingly contradictory and unstable position.

1988 Creates self-contained assemblage, *Kissing the Wall #2* [Plate 1], a newspaper- and enamel-covered piece of furniture (resembling a nightstand) with an incandescent light pointing at the wall.

This seminal work is freestanding, but it depends on the gallery wall as a screen, in the literal and metaphorical sense. The concept of "kissing" is playful and sensual: *"an emotionally charged event,"* the artist notes. Kissing breaks a formal boundary between two parties and carries the potential for a deeper engagement. It is no coincidence that Stockholder's art does this as well.

Awarded National Endowment for the Arts Grant in Sculpture.

Marries Patrick Chamberlain, a psychotherapist.

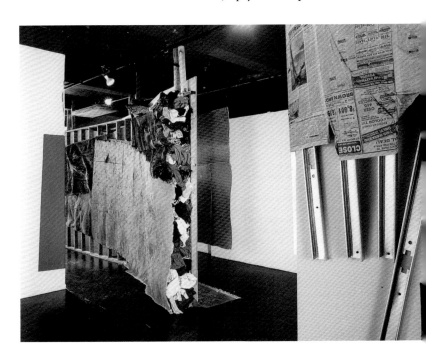

60

It's not over 'til the fat lady sings, 1987
Installation, Contemporary Art Gallery, Vancouver

1989 Installs *Making a Clean Edge* [Plate 59] at P.S.1 Contemporary Art Center, Long Island City, New York. "I didn't want my work to interfere with the other artists in the show and I didn't want theirs to interfere with mine. So I built the work with its back to the rest of the show. This work addressed itself to a big green skyscraper outside the window."

Stockholder's distinctive titles can be whimsical, often involving word play and dual meanings. Many begin with a grammatical gerund: *Making, Kissing, Nit Picking*. Gerunds avoid having a clear subject (the way "I make" or "You kiss" have subjects). Expressing present tense, they can imply action outside of time. Even after an installation is dismantled and known only through photographs and memory, the gerundive titles continue to generate action. This 1989 work, for example, is still "making a clean edge." Stockholder's frequent use of gerunds suggests she appreciates their ambivalent and category-straddling status.[7]

She often incorporates actual light, as in [Plate 22] or wires or objects that normally require electricity. We tend to perceive electric light as static, forgetting that it is a perpetually moving, dynamic force. Although electricity is a metaphor for many things, a pertinent analogy is that of a gallery visitor who can be either unplugged (in the sense of disengaged) or charged up (actively participating). Color cannot be seen without light. Including lights as part of the sculpture calls attention to the site-specific nature of color itself.

Awarded New York Foundation for the Arts Grant in Painting.

1990 Installs *Where it Happened* [Plate 61] at American Fine Arts Co., New York, along with studio works. "This was the first show I had in New York that really got some attention. It was very exciting. I showed studio works together with *Where it Happened*, something you bumped your way into through the awkward doors of the gallery to see the studio work in the back."

Jack Bankowsky wrote in *Artforum*, "In the large installation, *Where it Happened*, a bunch of real lemons set into the plaster, along with several abstract swatches of paint across the rubble, snapped the whole piece into a realm in which the pictorial was

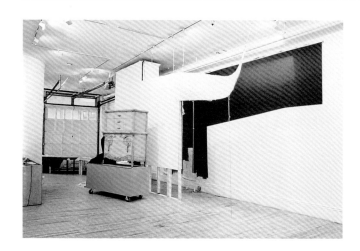

Where it Happened, 1990
Installation, American Fine Arts Co., New York

freed to be experienced both in formal terms and as pure artifice or convention. Suddenly the work suggested—not simulated or appropriated—an enormous Cubist still life come unhinged, a hyped-up, vertiginous burlesque of the generic genre. Stockholder never transcends or transforms the space she works with in the manner of much recent installation art; rather, she flat-footedly occupies it so that her intrusion is everywhere ham-fistedly present."[8]

1991 Installs *Recording Forever Pickled Too* [Plate 62] at Whitney Biennial, Whitney Museum of American Art, New York. "This work was different from, but related to, *Recording Forever Pickled*, which I made in France for the space of Le Consortium—a very big studio work. Ironically, this work was poorly sited in the Whitney. The space allocated for the work was fluid; the curator continued to make changes to how the work was sited after it had been made."

Many observers see Stockholder's aesthetic kinship to Robert Rauschenberg and his use of found objects (particularly his Combines of the 1950s). Stockholder herself notes, "Henri Matisse, Paul Cézanne, and the Cubists certainly are important to me. I also feel a strong affinity to Clyfford Still, Frank Stella, the New York School hard-edge painting and Minimalism, as well as Richard Serra."[9]

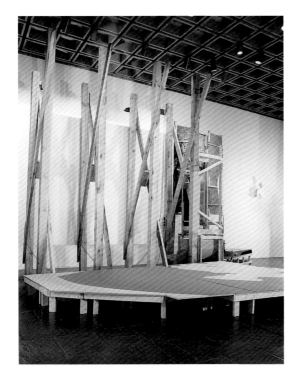

62

Recording Forever Pickled Too, 1991
Installation, Whitney Biennial, Whitney Museum of American Art, New York

63

Near Weather Wall, 1991
Installation, Witte de With Center for Contemporary Art, Rotterdam, The Netherlands

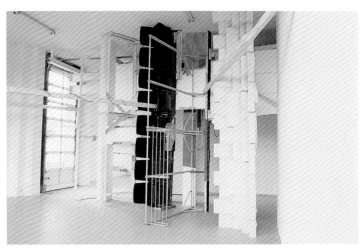

Installs *Near Weather Wall* [Plate 63] and *Making a Clean Edge II* [Plate 64] at Witte de With Center for Contemporary Art, Rotterdam, along with smaller works. "Here I made *Near Weather Wall* and rebuilt *Making a Clean Edge* (from P.S.1) and showed them together with work from the studio. Both larger works were about their connection to the outside of the building. This space had windows all around it. Weather and landscape have always mattered a great deal to me. Perhaps because I come from Vancouver."

The critical literature on Stockholder often links her to artists who use a "junk aesthetic" (e.g., Marcel Duchamp, Italian *arte povera* artists, and Rauschenberg). "A lot of people have written about my work in terms of junk. That I sometimes use junk doesn't seem of central importance to me. I use all kinds of things, old and new. Much of the stuff I use could be found in your living room."[10] "Stuff" is one of her favorite terms for describing the old and new materials she employs.

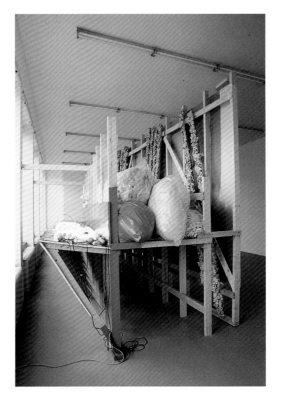

64

Making a Clean Edge II, 1991
Installation, Witte de With Center for Contemporary Art, Rotterdam, The Netherlands

1992 Installs *Growing Rock Candy Mountain Grasses in Canned Sand* [Plate 65] at Westfälischer Kunstverein, Münster, Germany.

This work addressed itself to the skylight-filled ceiling: 3,000 square feet of brilliant fuchsia spandex was suspended from cables, forming a mountainous landscape on the floor and casting pink throughout the white-walled room. Native Münsterland sandstone lay on the fabric and floor; a wall of gaseous concrete building blocks rose up; and newspaper and paint partially obscured the gallery wall.

The polyvalent connotations of fabric make it one of Stockholder's favorite materials. In *Growing Rock Candy Mountain . . .* , the spandex, most commonly used in swimsuits, was especially potent as a metaphor for skin. Here she again played on the symbolic connection between fabric, skin, and paint itself.

"Paint is a skin on a surface," she once said. "Your skin is between you and the world, separating you from it. . . . As a metaphor, skin speaks of the relationship between subjective and objective, a dichotomy parallel to that between fiction and reality. It is also a barrier or a façade."[11]

1994 Installs *Pink Lady* [Plate 66] at Weatherspoon Art Museum, The University of North Carolina at Greensboro, along with smaller works. "The blond floor overwhelmed and framed the pink, orange, and yellow waves of gesture as the figure stood still in the gallery. I was shocked at how extraordinarily friendly people were in Greensboro."

The experience of Stockholder's work has been likened to trips through old-fashioned discount stores like Kmart or Bargain Land, with their random assortments of cheap consumer items. On the use of "stuff" in her art, she has said: "I see it as a mesh of [Allan] Kaprow, [Jean] Tinguely, and the surrealists on the one hand, using chaos and chance—making systems out of happenings; and on the other hand meshing that kind of thinking with formal painting and minimalism. John Cage's thinking also had a lot of influence."[12]

Makes studio work [Plate 35] that includes a piece of furniture, plastic sink legs, clothing, paint, and plastic fruit.

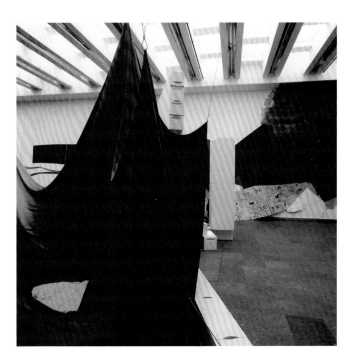

65

Growing Rock Candy Mountain Grasses in Canned Sand, 1992
Installation, Westfälischer Kunstverein, Münster, Germany

Stockholder frequently uses fruit—plastic and real—in her large and small works. Among other meanings, fruit invokes the art historical tradition of the still life. The genre reached its apogee in the seventeenth-century Netherlands. Dutch painters often depicted fruits, vegetables, and flowers precisely because they are perishable. As *memento mori,* they impart a moral lesson, reminding the viewer of the fleeting quality of earthly life.[13]

1995 Installs *Your Skin in this Weather Bourne Eye-Threads & Swollen Perfume* [Plate 17] at Dia Center for the Arts, New York.

Stockholder's installation at Dia in Chelsea was a tour de force—and particularly well received by the press. The accolades may have been partly due to the fact that after a decade of exhibiting major works primarily abroad, she had returned unequivocally to a hometown venue. *Your Skin . . .* presented an intricate maze of stops and starts, compromised vantage points, and a thorough engagement with, and deconstruction of, the entire gallery space it occupied at Dia.

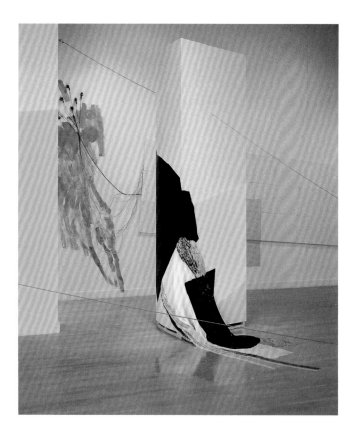

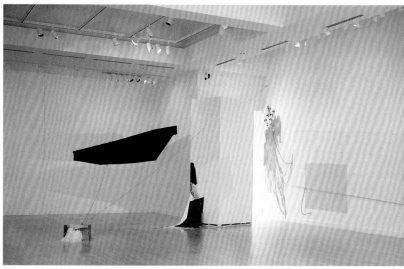

Pink Lady, 1994
Installation, Weatherspoon Art Museum, The University of North Carolina
at Greensboro

"I defy you not to be amazed," challenged art critic Peter Schjeldahl. Michael Kimmelman, the *New York Times* critic, rhapsodized, "Gorgeous may be an odd word to describe something made out of stackable plastic crates, extension cords and a swimming pool liner, among sundry detritus. But it is, well, stunning. . . . [I]ts scale is operatic, and so is its emotional pitch."[14]

Stockholder recalls the experience fondly: "Three months to install gave this work a very different feel—more layered and complex. It was a unique experience for me to have the time to work that way in the city where I lived. It was a real pleasure."

Makes sculpture [Plate 39] that is purchased by the Whitney Museum of American Art, New York. Stockholder's more general statement about her work applies well to this piece's incorporation of light and wheels:

"I hope that the finished object provides, if only for a brief moment, a site where myself and others can experience a confluence of inner life with concrete physical stuff. In this sense, and in other ways also, I think the work creates a static event. Visually not very much moves, except for the person viewing; but there are sparks flying through the air as electricity moves sight unseen through wires."[15]

67

Bowtied in the Middle, 1996
Installation, Rooseum Center for Contemporary Art, Malmö, Sweden

1996	Participates in **Painting—The Extended Field** at Rooseum Center for Contemporary Art, Malmö, Sweden, group exhibition, showing *Bowtied in the Middle* [Plate 67] installation and studio works. "I was eight months pregnant when I made this work. I don't think the title has much significance in relationship to the work. It is a corner piece, blowing into the corner."

Awarded John Solomon Guggenheim Fellowship Award in Visual Art.

Gives birth to a son, Charlie.

1998	Installs *Nit Picking Trumpets of Iced Blue Vagaries* [Plate 68] at Musée des Beaux-Arts de Nantes/ La Salle Blanche, Nantes, France.

Working in an atypical way, Stockholder spent six months in residence at the Atelier Calder in the Loire Valley, France, creating work for two locations in France: La Salle Blanche (Nantes) and the Musée Picasso (Antibes). Addressing "the massive, heavy feeling of the space" of La Salle Blanche, *Nit Picking Trumpets of Iced Blue Vagaries* included columns of stacked, upside-down buckets and painted easel-like objects slipping down the gallery's stone wall like fallen dominoes. Among other themes, the work contrasted heavy with light, balance with imbalance, plenitude with emptiness.

"It was an unusual opportunity to observe my process, as I arrived with nothing at an enormous empty studio. Watching myself fill it with material to work with was extraordinary."

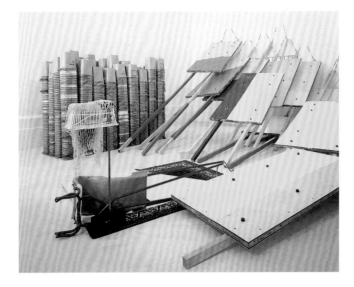

68

Nit Picking Trumpets of Iced Blue Vagaries, 1998
Collection Museum Moderner Kunst Stiftung Ludwig, Vienna

On constructing her installations, Stockholder has said: "The building process of my work is completely revealed, very clear and plain as day, and matter-of-fact. While at the same time something is hidden, not all is revealed. Perhaps the work is in some way a skin between what is visible and what is not."[16]

Installs *Landscape Linoleum* [Plate 69] outdoors at Openluchtmuseum voor beeldhouwkunst Middelheim, Antwerp, Belgium.

Stockholder comments on breaking completely outside of the white cube by creating her first major open-air installation: "Inserting ourselves into the landscape. An odd thing to do, given that we are here a priori."[17] *Landscape Linoleum* included a gigantic scaffolding from which gutted, painted cars hung vertically, vast regions of colored ground, and a large rectangular trench. She describes imagined music emerging from the "cut in the fabric of the scene," adding another invisible dimension to the experience of the work.

Shows studio works in **Chromaform: Color in Sculpture** [Plate 70], traveling group exhibition organized by Frances Colpitt, The University of Texas at San Antonio. "Color is not very popular as a place to focus conversation or to intellectualize about because it is so difficult to articulate why it is important and how it functions. It is subjective."

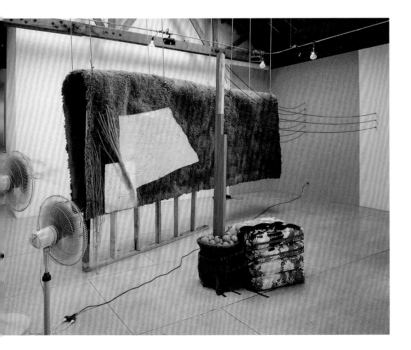

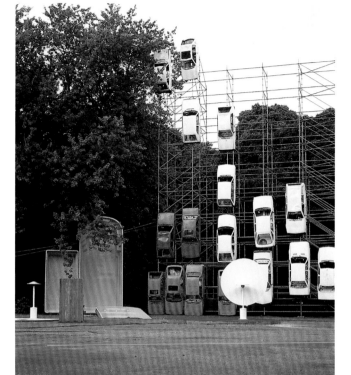

Stockholder's careful attention to the effects of color was highlighted by curator Colpitt, who characterized the sculptures in the exhibition as "not merely colored but *of* and *about* color as much as they are about materials and space, the more traditional concerns of sculptors."[18] Said Stockholder, "The works together in this show brought color alive and kicking as a protagonist onto the gallery stage."

Kay Stockholder passes away.

1999　Installs *First Cousin Once Removed or Cinema of Brushing Skin* [Plate 71] at The Power Plant, Toronto. "The building presented itself as a toy. It seemed small and model-like with the trailer truck butted up against it, the wall between, both sides (inside and out), acting as a movie screen for the still light, still life, of color. I very much enjoy working in Canada when I can. It's where I came from."

Accepts position as director of graduate studies in sculpture at Yale University. Moves to Hamden, Connecticut.

2000　Installs *Pictures at an Exhibition* as part of *Vortex in the Play of Theatre with Real Passion: In Memory of Kay Stockholder* [Plate 15] at Kunstmuseum St. Gallen, St. Gallen, Switzerland.

Although the notion of theatricality had long compelled her, this work made literal references to the stage through its room-high red curtain, linoleum flooring, storage containers, concrete blocks configured as steps, seating (in the form of a park bench), and a spotlight. During the months of planning for this project, Stockholder wrote to the curator, "Also I have a fantasy of using a whole bunch of Legos."[19]

An excerpt from her artist's statement expands on the work: "Sitting on the bench—an old woman is memory—eccentric activity, musty dust balls, in

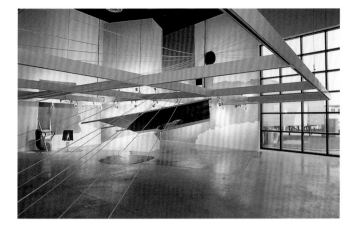

First Cousin Once Removed or Cinema of Brushing Skin, 1999
Installation, The Power Plant, Toronto

the glare of the lights, caught in the headlights like a photograph, phonograph, playing life."

She notes further, "After taking a job at Yale running the Sculpture Department, I started to wonder just what 'sculpture' is. Not an easy question to answer, but I think that theater has a lot to do with it these days.

"My mother, in addition to being a very theatrical person herself, spent her life studying Shakespeare."

2001 Installs *Bird Watching* [Plate 72] at SITE Santa Fe's Fourth International Biennial in New Mexico. "Who was watching whom? The designers of the exhibition and I together danced around each other. But you could watch birds while seated on one of the two benches."

The organizer of the SITE Santa Fe exhibition, Dave Hickey, called Stockholder's installation "interior decorating with a vengeance." He also contends she is one of the few artists who truly understands what "deconstruction really is, who knows what she's taking apart."[20]

Stockholder once expressed hope that visitors to her work will experience a struggle between different ways of viewing. (Among other modes of viewing, one might wonder if the work is a timeless art object or if it represents a real-life, time-bound experience.) "This struggle," Stockholder wrote, "presents a process of questioning rather than a fait accompli. It contributes to the rise of a kind of blur, a confusion of boundary, and it questions the possibility of containing bodies of information of ideas. Perhaps the best systems for knowing do not involve a stable unchanging mode of operation."[21]

Awarded August Seeling Prize, Freundeskreis Wilhelm Lehmbruck Museum, Duisburg, Germany.

2002 Installs *On the Spending Money Tenderly* [Plate 73] at Kunstsammlung Nordrhein-Westfalen, Düsseldorf, Germany. "Objects in public are not owned in the same way; they are shared. Things made, manipulated, and placed in public become sites of shared projections and engagement. They serve as bridges between us, shedding light on us as actors with the objects. This is a kind of public ritual. All heightened in the space of the white cube."[22]

2003 Installs *TV Tipped Toe Nails & the Green Salami* [Plate 19] at capc Musée d'art contemporain de Bordeaux, Bordeaux, France.

Stockholder transformed the grand nave of an 1824 Romanesque-style castle that had been used as a harbor warehouse. The work at once emphasized

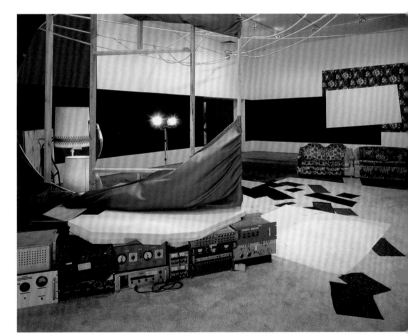

Bird Watching, 2001
Installation, SITE Santa Fe's Fourth International Biennial, Santa Fe

73

On the Spending Money Tenderly, 2002
Installation, Kunstsammlung Nordrhein-Westfalen, Düsseldorf, Germany

74

2003
Yellow bucket, yellow fake fur, teacup, wood, furniture legs, acrylic paint
23 × 12 in
58.4 × 30.5 cm

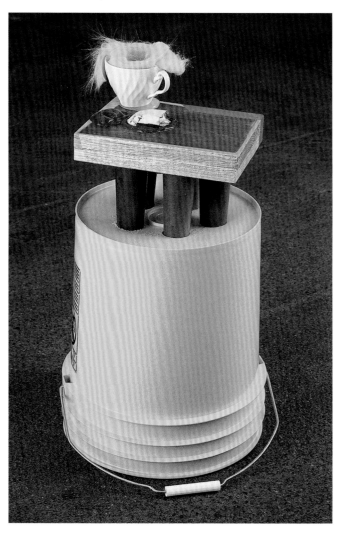

and negated the floor, using carpet, linoleum, platforms, and much paint. She hoped the viewer would experience it from both the nave and the balcony above.

"*TV Tipped Toe Nails & the Green Salami* intercepts this old castle, 19th century, coffee, vanilla, and spice storage facility. The stuff of fairy tales. And the Green Salami, the protagonist. Great big, slightly offensive, out of place, obscene, and also inanimate. The Green Salami is as a dream and as a metaphor. Of course the Green Salami has no body. It might not taste good but the words are fine.

"The building is already full of stories; it is intensely beautiful, full of comforting geometry, reason, mathematics, history, order, and the grid. Gravity is pushing down on these huge columns, pushing all of the atoms and molecules in the room towards the center of this spinning earth we are standing on in the quiet stillness of this big little room."[23]

Makes first completely freestanding studio work [Plate 74].

Installs **Table Top Sculpture** [Plates 3 and 4] at Gorney Bravin + Lee, New York, as part of a solo exhibition in which Stockholder invited other artists to participate with their own works. "This show included the work of thirty-nine other artists and about twenty works from my studio. Installing all the work together, I created a 'situation.' I was trying to peel a little of the white cube wallpaper back." (See "Interview with Jessica Stockholder" in this catalogue for a lengthy discussion of this exhibition.)

"[The works'] audacity is part of their appeal," wrote one critic. "How many artists would run a piece of fake fur from the wall to a table set with a yellow plastic flipper and a shower curtain painted in the manner of geometric abstraction? And what to call the assemblage of fake-crystal lamps, plastic buckets and portable radios with a painted tree trunk pushing through an end table in the center of the room?"[24]

2004 Presents studio works in **Kissing the Wall: Works, 1988–2003** at Blaffer Gallery, the Art Museum of the University of Houston, and Weatherspoon Art Museum, The University of North Carolina at Greensboro.

Curators Terrie Sultan and Nancy Doll organize a retrospective look at Stockholder's self-contained assemblages since 1988. The fact that these works still exist—unlike the site-specific environments—allows viewers to study them as compact, three-dimensional emblems of Stockholder's created world.

Creates installation for Rice University Art Gallery, Houston, in conjunction with opening of **Kissing the Wall** exhibition.

1. Jessica Stockholder, quoted in interview with Eva Schmidt, in *Jessica Stockholder* (Münster and Zurich: Westfälischer Kunstverein Münster/Kunsthalle Zürich, 1992), p. 43.

2. Jessica Stockholder, quoted in interview with Lynne Tillman, in *Jessica Stockholder* (London: Phaidon Press Ltd., 1995), p. 8.

3. Unattributed quotations by Jessica Stockholder come from discussions with Terrie Sultan or Nancy Doll in preparation for this book.

4. Although Stockholder's site-specific work is generally called installation art, she has noted the awkwardness of the term. Nevertheless, "installation" is a convenient description of work created specifically for a given architectural space or environment.

5. Interview with Eva Schmidt, p. 41.

6. Jessica Stockholder, artist's statement, in *It's not over 'til the fat lady sings* (Vancouver, Canada: Contemporary Art Gallery, 1987), pp. 10–11.

7. A gerund can behave like a noun while retaining certain characteristics of the verb. As verbal nouns, gerunds are permitted to take an object, despite their lack of a clear subject.

8. Jack Bankowsky, "The Obligatory Bed Piece," *Artforum* (October 1990): 145.

9. Jessica Stockholder, quoted in Klaus Ottman, "Interview with Jessica Stockholder," *The Journal of Contemporary Art* (Spring/Summer 1991). (Available online at www.jca-online.com/stockholder.html.)

10. Ibid.

11. Interview with Eva Schmidt, p. 43.

12. Ottman, "Interview with Jessica Stockholder."

13. The French (and French Canadian) term for still life is *nature mort.*

14. Peter Schjeldahl, "Out of Nothing," *The Village Voice,* October 24, 1995, p. 87, and Michael Kimmelman, "Exuberantly Operatic in Scale and Emotion," *The New York Times,* October 6, 1995, sec. C, p. 28.

15. Jessica Stockholder, "Parallel Parking," typescript of statement published in *Turn of the Century Magazine* (New York) (Spring 1993).

16. Jessica Stockholder, quoted in interview with Arielle Pélenc, in *Nit Picking Trumpets of Iced Blue Vagaries* (Nantes, France: Musée des Beaux-Arts de Nantes, 1998).

17. Jessica Stockholder, *Landscape Linoleum* (Antwerp, Belgium: Openluchtmuseum voor beeldhouwkunst Middelheim, 1998), p. 13.

18. Frances Colpitt et al., *Chromaform: Color in Sculpture* (San Antonio: The University of Texas at San Antonio, 1998), p. 7.

19. Konrad Bitterli, "From Conception to Realization: The Genesis of *Vortex in the Play of Theatre with Real Passion*," in *Jessica Stockholder: Vortex in the Play of Theatre with Real Passion* (Nüremberg, Germany: Verlag für modern Kunst, 2001), p. 46.

20. Dave Hickey, quoted in Linda Yablonsky, "Even the Kitchen Sink," *ARTnews* (May 2003): 139.

21. Jessica Stockholder, "Parallel Parking."

22. Jessica Stockholder, *On the Spending Money Tenderly* (Düsseldorf, Germany: Kunstsammlung Nordrhein-Westfalen, 2002), p. 92.

23. Jessica Stockholder, *TV Tipped Toe Nails & the Green Salami* (Bordeaux, France: capc Musée d'art contemporain de Bordeaux, 2003), p. 58.

24. Linda Yablonsky, "Art Reviews: Jessica Stockholder," *Time Out/New York,* October 23–30, 2003, p. 79.

SELECTED EXHIBITIONS AND PUBLICATIONS, 1982–2003

One-person exhibitions are indicated in color.

1982

Graduation Exhibition, McPherson Library Gallery, University of Victoria, Victoria, Canada, April 20–30.

Re:Constructivism, Open Space Gallery, Victoria, Canada.

Vilio Celli, Laurie Metters, Jessica Stockholder, Open Space Gallery, Victoria, Canada.

1983

Installation in My Father's Backyard, installation, private residence, Vancouver.

1984

In-side out, installation, Art Culture Resource Center, Toronto, July.

1985

Collaboration between Mark Holmes and Jessica Stockholder, involving a permanently installed sculpture by Isamu Noguchi, Beinecke Plaza, Yale University, New Haven, Connecticut, May.

Wall Sandwich, installation, Melinda Wyatt Gallery, New York, August.

Selections from the Artist's File, *The Lion, the Witch and the Wardrobe*, installation, Artists Space, New York. Catalogue, text by Kay Larson.

Thesis Exhibition, *Bath*, installation, Yale University, New Haven, Connecticut.

1987

It's not over 'til the fat lady sings, installation, Contemporary Art Gallery, Vancouver, September 1–26. Catalogue, text by Mark Holmes.

> Perry, Art. "Appreciating Creative Fun." *The Province* (Vancouver), September 11, 1987.

1988

Artists and Curators, John Gibson Gallery, New York, September.

Jessica Stockholder: Sculpture and Installation, *Indoor Lighting for My Father*, installation, Mercer Union, Toronto, September 6–October 1.

1989

A Climate of Site, Barbara Farber Gallery, Amsterdam, January. Catalogue, text by Robert Nickas.

Group exhibition, *Making a Clean Edge*, installation, P.S.1 Contemporary Art Center, Long Island City, New York, April.

Berkshire Art Association 1989 Exhibition of Painting and Sculpture, Berkshire Museum, Pittsfield, Massachusetts, September. Catalogue, text by Lisa Phillips.

The Mattress Factory: Installation and Performance, *Mixing Food with the Bed*, installation, The Mattress Factory, Pittsburgh. Catalogue, text by Jessica Stockholder.

> Homisak, Bill. "At 1414 Monterrey, Art Moves 'Off the Wall.'" *Pittsburgh Tribune Review*, October 20, 1989.

> Miller, Donald. "Victor Grauer, Kathleen Montgomery, Cady Noland, Jessica Stockholder." *Pittsburgh Post-Gazette*, October 21, 1989.

1990

Information, Terrain, San Francisco, January.

Pop 90, Postmasters Gallery, New York, January.

Where it Happened, installation and studio works, American Fine Arts Co., New York, February.

> Mahoney, Robert. "Jessica Stockholder: Where it Happened." *Sculpture* (November/December 1990).

> Ruzicka, Joseph. "Jessica Stockholder." *Art in America* (September 1990).

> Smith, Roberta. "Jessica Stockholder." *The New York Times*, March 2, 1990.

Saltz, Jerry. "Notes on a Sculpture: Mis-appropriation, Jessica Stockholder's Sculpture with No Name." *Arts Magazine* (April 1990).

Stendhal Syndrome: The Cure, Andrea Rosen Gallery, New York, June 29–August 4. Catalogue, text by Rhonda Lieberman, Catherine Liu, and Lawrence Rickels.

> Seigel, Jeanne. "Jessica Stockholder." *Arts Magazine* (June 1990).

Detritus: Transformation and Re-construction, Jack Tilton Gallery, New York, July–August.

Contingent Realms: Four Contemporary Sculptors, Whitney Museum of American Art at Equitable Center, New York, September–December. Catalogue, text by Adam Weinberg.

> Parks, Addison. "Going It Alone with Sculpture." *The Christian Science Monitor*, November 29, 1990.

Mary Heilmann and Jessica Stockholder, *For Mary Heilmann*, installation, Isabella Kacprzak Galerie, Cologne, October.

The Technological Muse, Katonah Museum of Art, Katonah, New York, November 11–February 3, 1991. Catalogue, text by Susan Fillen-Yeh.

Stuttering, Stux Gallery, New York, December.

Le choix des femmes, *Recording Forever Pickled*, installation, Le Consortium, Dijon, France. Catalogue, text by Eric Colliarc, René Denizot, Xavier Douroux, Frank Gautherot, and Bernard Marcadé.

> Dupont, Valerie. "Le choix des femmes." *Art en Bourgogne* (Summer 1990).

1991

The Broken Mirror, UNTITLED *Seepage: Sandwashed, Sundried & Shrink-wrapped*, installation, The Ezra and Cecile Zilkha Gallery, Center for the Arts, Wesleyan University, Middletown, Connecticut, January 29–March 3.

> Decter, Joshua. "Jessica Stockholder." *Arts Magazine* (May 1991).

Physicality: An Exhibition on Color Dimensionality in Painting, The Gallery, New York, March. Catalogue, text by George Hoffman.

Mahoney, Robert. "Jessica Stockholder." *Tema Celeste* (March/April 1991): 80–81.

Ottman, Klaus. "Interview with Jessica Stockholder." *The Journal of Contemporary Art* (Spring/Summer 1991): 96–100.

The Museum of Natural History, Barbara Farber Gallery, Amsterdam, April. Catalogue, text by Barbara Farber.

Outside America: Going into the 90s, Fay Gold Gallery, Atlanta, April. Catalogue, text by Tricia Collins and Richard Milazzo.

Whitney Biennial 1991, *Recording Forever Pickled Too*, installation, Whitney Museum of American Art, New York, April 2–June 30. Catalogue, text by Richard Armstrong, John G. Hanhardt, Richard Marshall, and Lisa Phillips.

> De Bruyn, Eric. "Whitney Biennale." *Forum International* (Antwerp) (September 1991).

> Johnson, Ken. "Generational Saga." *Art in America* (June 1991).

Peter Nadin and Jessica Stockholder, Warren Adelson Gallery, New York, April 10–May 4. Catalogue, text by Thea Westreich.

Sculptors' Drawings, Paula Cooper Gallery, New York, May.

Jessica Stockholder, Daniel Weinberg Gallery, Santa Monica, California, May 9–June 8.

> Curtis, Cathy. "Objects of Her Affection." *Los Angeles Times*, May 17, 1991: Sec. F, p. 15.

> Pagel, David. "Jessica Stockholder." *Arts Magazine* (October 1991): 89.

Le Consortium Collectionne, *Recording Forever Pickled*, installation, Le Consortium, Chateau d'Oiron, Dijon, France, June–October. Catalogue.

Formalism and Its Other, Jessica Stockholder, *Near Weather Wall* and *Making a Clean Edge II*, installation and studio works, Witte de With Center for Contemporary Art, Rotterdam, June 15–July 28. Catalogue, text by John Miller.

> Lambrecht, Luk. "Jessica Stockholder." *Forum International* (Antwerp) (September 1991).

> von Graevenitz, Antje. "Jessica Stockholder: Making a Clean Edge." *Archis* (Amsterdam) (July 1991).

Skin Toned Garden Mapping, installation, The Renaissance Society at the University of Chicago, Chicago, October 1–November 10.

> Glatt, Clara. "Installation Finds Meaning in Everyday Objects." *Chicago Herald*, October 30, 1991.

> Hixson, Kathryn. "Jessica Stockholder." *Arts Magazine* (January 1992): 88.

Plastic Fantastic Lover (object a), installation, Blum Helman Warehouse, New York, October 12–November 9. Catalogue, text by Catherine Liu.

American Artists of the Eighties, Palazzo delle Albere, Museo Provinciale d'Arte, Trento, Italy, December. Catalogue, text by Jerry Saltz.

Jürgen Meyer, Jessica Stockholder, Franz West, Christine Burgin Gallery, New York, December.

> Faust, Gretchen. "Jessica Stockholder." *Arts Magazine* (March 1992).

1992

Sichel, Berta. "Undomesticated Still Lifes: The Order and Disorder of Jessica Stockholder." *Balcon No. 7* (January 1992).

Jessica Stockholder, *Growing Rock Candy Mountain Grasses in Canned Sand*, installation, Westfälischer Kunstverein, Münster, Germany, April 10–May 31, and *Sea Floor Movement to Rise of Fireplace Stripping*, installation, Kunsthalle Zurich, Zurich, October 31–January 3, 1993. Catalogue, text by Friedrich Meschede, Eva Schmidt, and Antje von Graevenitz.

> Grasskamp, Walter. "Im Büchsensand." *Frankfurter Allgemeine Zeitung*, May 13, 1992.

> Lettmann, Achim. "Badestoffim Raum." *Scester Anzeiger*, April 11–12, 1992.

> Rochol, Hans. "Sinnliches Serherlebnis." *Die Glock*, April 15, 1992.

Cultural Fabrication, John Good Gallery, New York, June.

Women Artists Not Included in Documenta IX, Kunstlerhaus Stuttgart, Stuttgart, Germany, June.

Mary Heilmann, Jack Pierson, Jessica Stockholder, Pat Hearn Gallery, New York, September.

> Myers, Terry R. "Heilmann, Pierson, Stockholder." *Flash Art* (November/December 1992): 98–99.

Westfall, Stephen. "Interview with Jessica Stockholder." *Bomb* (September 1992).

Transgressions in the White Cube: Territorial Mappings, Suzanne Lemberg Usdan Gallery, Bennington College, Bennington, Vermont, November. Catalogue, text by Joshua Decter.

Flower Dusted Prosies, installation, American Fine Arts Co., New York.

> Tager, Alisa. "Jessica Stockholder." *Tema Celeste* (Autumn 1992).

SpICE BOXed Project(ion), installation, Galerie Metropol, Vienna.

> Kravagna, Christian. "Jessica Stockholder/Galerie Metropol." *Artforum* (January 1993): 95.

> Kurjakovic, Daniel. "Jessica Stockholder." *Flash Art* (January/February 1993): 99–100.

> Polzer, Brita. "Jessica Stockholder." *Kunstbulletin* (December 1992).

1993

Simply Made in America, The Aldrich Museum of Contemporary Art, Ridgefield, Connecticut, January 24–May 2. Traveled to Contemporary Arts Center, Cincinnati, February 2–March 24, 1994. Catalogue, text by Barry Rosenberg.

Mettlesome & Meddlesome: Selections from the Collection of Robert J. Schiller, Contemporary Arts Center, Cincinnati, February 6–March 20. Catalogue, text by Elaine King, Jan Riley, Robert Schiffler, and Marcia Tucker.

Stockholder, Jessica. "Parallel Parking." *Turn of the Century Magazine* (New York) (Spring 1993).

Anniversary Exhibition, Daniel Weinberg Gallery, Santa Monica, California, April.

Ordnung und Zerstorung, Lothringer Strasse 13, Munich, May.

Edge of Hothouse Glass, installation, Galerie des Arènes, Carré d'Art, Musée d'Art Contemporain de Nîmes, Nîmes, France, May 6–September 26. Catalogue, text by Jan Avgikos, Olivier Mosset, and Jessica Stockholder.

The Good, the Bad, and the Ugly . . . a Modest Proposal, Galerie Jousse Seguin, Paris, May 25–June 30.

Jours Tranquilles à Clichy, 40, Rue de Rochechouart, Paris, June. Traveled to Tennisport Arts, New York, September.

Testwall: Small 3 Dimensional Multiples, TZ'Art & Co, New York, November.

Group exhibition, Galerie Nathalie Obadia, Paris, November 27–January 6, 1994.

> Butler, Connie. "Terrible Beauty and the Enormity of Space." *Art & Text* (September 1993).

> Donegan, Cheryl. "One Portrayal, Four Portraits." *Tema Celeste* (Winter 1992–93).

> Liebmann, Lisa. "Junk Cultured." *frieze* (March/April 1993).

As Long As It Lasts, *Catcher's Hollow*, installation, Witte de With Center for Contemporary Art, Rotterdam. Catalogue, text by Patrick Chamberlain and Jessica Stockholder.

> Pontzen, Rutger. "Geschilder in de ruimte." *Vrij Nederland* (The Netherlands), July 10, 1993.

> van den Boogerd, Dominic. "As Long As It Lasts." *Metropolis M* (The Netherlands) (August).

Jessica Stockholder, Galerie George Ludwig, Krefeld, Germany.

1994

The Beauty Show, Four Walls, Brooklyn, New York, January.

Joan Snyder and Jessica Stockholder, Jay Gorney Modern Art, New York, January.

> Harris, Susan. "Joan Snyder and Jessica Stockholder." *Art Press* (Paris) (April 1994).

> Hess, Elizabeth. "Fem Fatale." *The Village Voice*, January 25, 1994.

> Kimmelman, Michael. "Joan Snyder and Jessica Stockholder." *The New York Times*, February 4, 1994.

> Levin, Kim. "Voice Choice: Joan Snyder and Jessica Stockholder." *The Village Voice*, February 1, 1994.

> Slatin, Peter. "Joan Snyder, Jessica Stockholder." *ARTnews* (May 1994).

Possible Things: A Drawing Show, Bardamu Gallery, New York, January. Catalogue, text by Vik Muniz.

Reveillon '94, Stux Gallery, New York, January.

Untitled . . . , Postmasters Gallery, New York, March.

Unbound: Possibilities in Painting, *Fat Form and Hairy: Sardine Can Peeling*, installation, Hayward Gallery, London, March 3–May 30. Catalogue, text by Adrian Searle.

> Bachelor, David. "Behind a Painted Smile: . . . 'Unbound'" *frieze* (May 1994).

> Cork, Richard. "Painting is Back in the Picture." *The Times* (London), March 7, 1994.

> Morley, Simon. "Unbound: Possibilities in Painting." *Art Monthly* (London) (April 1994).

> Myerson, Clifford. "On Painting 1." *Art Monthly* (London) (September 1994).

> Norman, Geraldine. "Exhibition Highlights New Wave of Painting 'Unbound' for Success." *The Independent* (London), March 14, 1994.

Pink Lady, installation and studio works, Weatherspoon Art Museum, The University of North Carolina at Greensboro, April 3–May 29. Catalogue, text by Trevor Richardson.

> Joanes, Abe. "Sculptor's Work Explores the Material World." *Greensboro News & Record*, March 27, 1994.

> Patterson, Tom. "Jessica Stockholder's Works Hold Attention, Test the Mind." *Winston-Salem Journal*, May 1, 1994.

John Dunn, Adelheid Mers, Carla Preiss, Jessica Stockholder, N.A.M.E. Gallery, Chicago, April 8–May 14.

Balkenhol, Dunham, Gilliam, Hirst, McCaslin, Stockholder, Weinstein, Baumgartner Galleries, Washington, D.C., July.

The Little House on the Prairie, Marc Jancou Gallery, London, September.

Symphonie en Sous-Sol, Galerie Renos Xippas, Paris, September.

Ethereal Materialism, Apex Art, New York, November.

Joe's Garage, TZ'Art & Co., New York, December 1–24.

Country Sculpture, *House Beautiful*, installation, Le Consortium, Dijon, France.

> Bouisset, Maïten. "Le Consortium: Deux Collections à l'Université." *Art Press* (Paris) (February 1994).

don't look now, Thread Waxing Space, New York. Catalogue, text by Joshua Decter.

Information Service, Goethe House, New York.

1995

On Target, Horodner Romley Gallery, New York, January.

Sweet for Three Oranges, installation, Fundación 'la Caixa,' Barcelona, January 18–February 26. Catalogue, text by Jessica Stockholder and Jeffrey Swartz.

> Juncosa, Enrique. "Abetos y naranjas." *El Pais* (Barcelona), February 4, 1995.

> Spiegel, Olga. "La Norteamericana Jessica Stockholder abre temporada en la sala Montcada." *La Vanguardia* (Barcelona), January 21, 1995.

Smaller Works, S. L. Simpson Gallery, Toronto, February.

> Taylor, Kate. "Of Green Shower Curtains and Lavender Fuzzy Fur." *The Globe and Mail* (Toronto), February 11, 1995.

Jessica Stockholder, Jay Gorney Modern Art, New York, March 25–April 29.

> Myers, Terry R. "Jessica Stockholder." *New Art Examiner* (June 1995).

> Servetar, Stuart. "Jessica Stockholder." *N.Y. Press*, March 30, 1995.

> Servin, James. "Abstract Artist Brings Home the Familiar." *Associated Press*, April 14, 1995.

> Smith, Roberta. "Jessica Stockholder." *The New York Times*, April 14, 1995.

Color in Space: Pictoralism in Contemporary Sculpture, David Winton Bell Gallery, List Art Center, Brown University, Providence, Rhode Island, April. Catalogue, text by George Hoffman.

1995 Collectie Presentatie Moderne Kunst, Centraal Museum Utrecht, Utrecht, The Netherlands, April.

Wachtmeister, Marika. "Interview, Jessica Stockholder." *Femina* (Stockholm) (October).

Your Skin in this Weather Bourne Eye-Threads & Swollen Perfume, installation, Dia Center for the Arts, New York, October 5–June 21, 1996. Catalogue, text by Lynne Cooke, Michael Govan, Anne Lauterbach, Jessica Stockholder, and Lynne Tillman.

> Aukeman, Anastasia. "Jessica Stockholder/Dia." *C Magazine* (Toronto) (Spring 1996): 48.

> Grant, Annette. "Praising Famous Men, and an Empire or Two." *The New York Times*, December 29, 1995, sec. H, p. 37.

> Iannacci, Anthony. "Installation als Illustration eines Denkprozesses: Jessica Stockholder im Dia Center for the Arts, New York." *Kunst Bulletin* (Zurich) (April 1996): 8–15.

> Jaeger, Jack. "Jessica Stockholder/Dia Art Foundation." *Zapp Magazine* (Amsterdam), no. 8 (1995).

> Kimmelman, Michael. "Exuberantly Operatic in Scale and Emotion." *The New York Times*, October 6, 1995, p. 28.

> McDonough, Thomas F. "Your Skin . . . Jessica Stockholder in Dia Center for the Arts." *Texte zur Kunst* (March 1995): 185–87.

> Molesworth, Helen. "Jessica Stockholder/Dia Art Foundation." *frieze* (May 1996): 68–69.

> Mumford, Steve. "Art and Objecthood Redux: Jessica Stockholder at Dia." *Review* (June 1996): 10–11.

> Stockholder, Jessica. "Self-portrait by Jessica Stockholder." *The New Yorker* (March 4, 1996): 36.

> Volk, Gregory. "Jessica Stockholder/Dia Center for the Arts." *ARTnews* (January 1996): 125.

Re:Fab Painting Abstracted, Fabricated, and Revised, Contemporary Art Museum, University of South Florida, Tampa, October 30–December 22. Traveled to Frances Wolfson Gallery, Miami Dade College, Miami, November 6–December 20, 1996, and Art Gallery of the University of Vermont, Burlington, January 21–April 20, 1997. Catalogue, text by Rochelle Feinstein, Shirley Kaneda, Margaret A. Miller, WJT Mitchell, and Christine Van Schoonbeck.

Studio works, Galerie Nathalie Obadia, Paris, December 9–January 27.

> Dagen, Phillippe. "Jessica Stockholder." *Le Monde* (Paris), January 15, 1996, p. 19.

Painting Outside Painting: 44th Biennial Exhibition of Contemporary American Painting, The Corcoran Gallery of Art, Washington, D.C., December 16–February 19, 1996. Catalogue, text by Terrie Sultan et al. Text on the artist by David Pagel.

Elena Sisto, Lisa Hoke, Jessica Stockholder, Dru Arstark Gallery, New York.

Pittura/Immedia: Malerei in den 90er Jahren, *Recording Forever Pickled Too*, installation, Neue Galerie am Landesmuseum Joanneum Graz, Graz, Austria. Catalogue, text by Thomas Dreher and Peter Weibel.

Vogel, Sabine B. "In der Satelitenschussel." *Frankfurter Allgemeine Zeitung*, March 23, 1995.

Schwabsky, Barry, Lynne Tillman, and Lynne Cooke. *Jessica Stockholder*. London: Phaidon Press Ltd., 1995.

1996

Studio works, Studio La Città II, Verona, Italy, January 21. Catalogue, text by Anthony Iannacci.

Meneghelli, Luigi. "Cultura: Gli oggetti di Jessica." *L'Arena* (Verona), February 22, 1992, p. 32.

Panzera, Mauro. "Spotlight: Jessica Stockholder." *Flash Art* (Summer 1996): 79.

Spada, Sabina. "Jessica Stockholder." *Tema Celeste* (Spring 1996): 61.

Square Bubbles, Nott Memorial Art Museum, Union College, Schenectady, New York, March 8–April 21.

Painting in an Expanding Field, Usdan Gallery, Bennington College, Bennington, Vermont, March 26–April 19. Catalogue, text by M. C. Harris.

Bowtied in the Middle, installation and studio works, Tom Solomon's Garage, Los Angeles, April–May.

Frank, Peter. "Jessica Stockholder, Joyce Lightbody." *L.A. Weekly*, May 3–9, 1996, p. 122.

Knight, Christopher. "Jessica Stockholder at Tom Solomon's Garage." *art issues* (September/October 1996): 38.

Pagel, David. "Having and Using. . . ." *Los Angeles Times*, April 25, 1996, sec. F, p. 11.

Forms als Zeil mündet immer in Formalismus (Mies van der Rohe), Galerie Rolf Ricke, Cologne, June 7–August 10.

Luminous Bodies, Rotunda Gallery, Brooklyn, New York, September 19–November 2. Catalogue.

Jessica Stockholder: 200 Drawings, Baxter Gallery, Maine College of Art, Portland, September 27–October 25. Traveled to Ben Maltz Gallery, Otis College of Art and Design, Los Angeles, October 10–November 3, 1997. Catalogue, text by Jennifer Gross.

Wilson, William. "Sketches Whet Appetite for Stockholder's Final Product." *Los Angeles Times*, October 7, 1997, sec. F, p. 6.

Painting—The Extended Field, *Bowtied in the Middle*, installation and studio works, Rooseum Center for Contemporary Art, Malmö, Sweden, October 5–December 15 and January 25–April 6, 1997, and Magasin 3 Stockholm Konsthall Stockholm, October 13–December 19 and February 2–April 20, 1997. Catalogue, text by Sven-Olov Wallenstein.

Patterns of Excess, Beaver College Art Gallery, Glenside, Pennsylvania, November 7–December 20. Catalogue, text by Paula Marincola and Ingrid Schaffner.

Unconditionally Abstraction, Schmidt Contemporary Art, St. Louis, November 23–December 20. Catalogue.

Millennium Eve Dress, The Fabric Workshop and Museum, Philadelphia, December 6–February 22, 1997. Traveled to Contemporary Arts Center, Cincinnati, November 15–January 11, 1998.

The 20th Century Art Book. London: Phaidon Press Ltd., 1996.

1997

Wandstücke IV, Bob van Orsouw Galerie, Zurich, January 17–February 22.

Jessica Stockholder, Jay Gorney Modern Art, New York, April 5–May 10.

Arning, Bill. "Jessica Stockholder." *Time Out/New York*, May 1–8, 1997, p. 37.

Across Lines, Rosenberg Gallery, Hofstra University, Hempstead, New York, April 23–May 3.

Jessica Stockholder: Drawings at Deutscher Akademischer Austauschdienst, Deutscher Akademischer Austauschdienst, Berlin, April 25–May 24.

Müller, Katrin Bettina. "Schiffbruch im Zimmer: Zweimal Jessica Stockholder bei D.A.A.D. und Contemporary Fine Arts." *Die Tageszeitung*, May 17, 1997, p. 24.

Tietenberg, Annette. "Wenn Jessica Stockholder Kombiniert." *Frankfurter Allgemeine Zeitung*, May 10, 1997, p. 40.

Weinsowski, Ingeborg. "Kunst: Jessica Stockholder." *Spiegel Extra: Das Kultur-Magazin* (May 1997): 22.

Colorflex, apexart, New York, May 29–June 28. Catalogue, text by Raphael Rubenstein.

La Biennale di Venezia: 47th Esposizione Internazionale d'arte, *Recording Forever Pickled*, installation, Corderie Building, Venice, June 15–November 9. Catalogue, text by Franco Fanelli.

Onomatopoeia, Studio La Città, Verona, Italy, July 5–August 30.

4e Biennale de Lyon, *Bowtied in the Middle*, installation, Halle Tony Garnier, Lyon, France, July 9–September 24. Catalogue, text by Olivier Kaeppelin, Thierry Prat, Thierry Raspail, and Harald Szeemann.

New York—Divergent Models, Nassauischen Kunstverein, Wiesbaden, Germany, September 7–October 19.

The Point of Departure: Moira Dryer and Jessica Stockholder, Gallery of Art, Johnson County Community College, Overland Park, Kansas, September 21–October 29. Brochure, text by Saul Ostrow.

Slab of Skinned Water, Cubed Chicken & White Sauce, installation, Kunstnernes Hus, Oslo, October 25–November 23. Catalogue, text by Jessica Stockholder, Åsmund Thorkildsen, and Ståle Vold.

> Grogaard, Stian, and Ingvill Henmo. "Et plutselig mykt trinn" and "I bildets mage." *Morgenbladet*, October 31, 1997, p. 9.

> Hedberg, Hans. "Stockholder kommunicerar med världen." *Svenska Dagbladet* (Stockholm), November 8, 1997, sec. E.

Heart, Mind, Body, Soul: American Art in the 1990s, Selections from the Permanent Collection, Whitney Museum of American Art, New York, November 26–January 4, 1998.

Jessica Stockholder: 9 Installations. Artist book, edition of 75, signed/numbered. Paris: Edition du Centre d'art imprimé, 1997.

1998

Nit Picking Trumpets of Iced Blue Vagaries, installation, Musée des Beaux-Arts de Nantes/La Salle Blanche, Nantes, France, January 14–April 13. Catalogue, text by Arielle Pélenc and Jessica Stockholder.

> Arkhipoff, Elisabeth. "Artiste du Mois: Stockholder." *Beaux Arts Magazine* (March 1998): 23.

> Régnier, Philippe. "Stockholder, l'après Calder." *Le Journal des Arts*, January 16, 1998.

Torque, Jelly Role, and Goose Bump, installation, Musée de Picasso d'Antibes, Antibes, France, January 16–March 22. Catalogue, text by Jean-Pierre Criqui, Thierry Davila, and Jessica Stockholder.

Alternative Measures, Castle Gallery, College of New Rochelle, New Rochelle, New York, February 1–April 5. Catalogue, text by Susan Canning.

Jessica Stockholder, Coupling, installation, White Cube, London, April 24–May 30.

> Ohrt, Robert. "05.98 Kunst: Extra Pelzig!" *Cosmopolitan* (Munich) (May 1998): 16.

Turning Paper: Monotypes from Two Palms Press, Betsy Senior Gallery, New York, April 30–June 5. Traveled to Galerie Nathalie Obadia, Paris, October 24–December 1.

Young Americans Two: New American Art at the Saatchi Gallery, *Bowtied in the Middle*, installation and studio works, Saatchi Gallery, London, April 30–July 12. Catalogue, text by Brooks Adam and Lisa Liebmann.

Exploiting the Abstract, Feigen Contemporary, New York, May 2–June 13.

Humble County, D'Amelio Terras, New York, June 11–July 31.

Painting Language, LA Louver Gallery, Los Angeles, August 5–September 5.

Chromaform: Color in Sculpture, UTSA Art Gallery, The University of Texas at San Antonio, San Antonio, September 3–October 16. Traveled to University of North Texas Art Gallery, Denton, November 5–December 12; Nevada Institute for Contemporary Art, Las Vegas, April 8–May 23, 1999; University Art Gallery, New Mexico State University, Las Cruces, June 12–August 12; University Art Gallery, Sonoma State University, Rohnert Park, California, November 11–December 17; Edwin A. Ulrich Museum of Art, Wichita State University, Wichita, January 21–March 7, 2000; and Mount Holyoke College Art Museum, South Hadley, Massachusetts, April 7–June 30. Catalogue, text by Frances Colpitt et al. Text on the artist by Ann Wood.

Landscape Linoleum, installation, Openluchtmuseum voor beeldhouwkunst Middelheim, Antwerp, Belgium, September 6–November 15. Catalogue, text by Menno Meewis, Greg Hilty, and Jessica Stockholder.

> Hagoort, Erik. "Bij Stockholder vecht een badkuip met de verf." *De Volle Iuzant* (October 1998): 22.

> Roelandt, Els. "Kleur bekennen." *Tyd & Cultur* (September 2, 1998).

> Vanbelleghem, Kurt. "Jessica Stockholder." *The Bulletin*, October 8, 1998.

Interpreting: Lynne Cooke, Lia Gangitano, Robert Storr and Lydia Yee, The Rotunda Gallery, Brooklyn, New York, September 10–October 17.

Fabian Marcaccio and Jessica Stockholder, Works on Paper, Inc., Los Angeles, October 3–November 14.

Fabian Marcaccio and Jessica Stockholder, Sammlung Goetz, Munich, October 12–March 27, 1999. Catalogue, text by Fabian Marcaccio, Jessica Stockholder, Friedrich Meschede, Christiane Meyer-Stoll, David Ryan, and Eva Schmidt.

Auf der Spur: Kunst der 90er Jahre im Spiegel von Schweizer Sammlungen, Kunsthalle Zurich, Zurich, October 30–December 27.

Dijon/Le Consortium, *House Beautiful* and *Recording Forever Pickled*, installations, Centre Georges Pompidou, Museé National d'Art Moderne, Paris, November 4–December 14.

I Love New York: Crossover der aktuellen Kunst, Museum Ludwig Cologne, Cologne, November 6–January 31, 1999. Catalogue.

Coming Off the Wall, Susquehanna Art Museum, Harrisburg, Pennsylvania, November 11–March 5, 1999.

Studio works, Catriona Jeffries Gallery, Vancouver, Canada, November 19–January 16, 1999.

1999

Castro, X. Anton. "La Pintura como dilucion de los Generos [Painting as the Dilution of Genres]." *Lapiz* (Madrid) (January/February 1999): 170–77.

Milroy, Sarah. "Jessica Stockholder's Material World." *The Globe and Mail Visual Arts* (Vancouver), January 2, 1999.

Special Offer: Eine Ausstellung des Kölner Galeristen Rolf Ricke, Kasseler Kunstverein, Kassel, Germany, March 14–April 11. Catalogue.

Studio works, Galerie Rolf Ricke, Cologne, April 23–June 4.

JPK. "Ausstellung Stockholder: Uberraschende Bezuge." *Kolner Stadt-Anzeiger*, May 28, 1999, p. 28.

Puvogel, Renate. "Jessica Stockholder." *Kunstforum International* (Germany) (July/August 1999): 382–83.

Re: Rauschenberg, Marcel Sitcoske Gallery, San Francisco, May 6–July 3.

First Cousin Once Removed or Cinema of Brushing Skin, installation, The Power Plant, Toronto, June 25–September 6. Catalogue, text by Marc Mayer and Jessica Stockholder.

Solomon, Deborah. "Domesticity Is Bliss: Jessica Stockholder's deeply cultured installation art offers a zany, profound view of history as décor." *Time* (Canada) (July 12, 1999): 48–49.

Whyte, Murray. "In an Era Obsessed With Meaning, a Pure Abstraction." *National Post* (Vancouver), June 25, 1999.

With Wanton Heed and Giddy Cunning Hedging Red and That's Not Funny, installation, Center for Visual Arts, Cardiff, Wales, September 1–November 7. Catalogue, text by Alex Farquharson, Sally Medlyn, Jennifer Higgie, and Jessica Stockholder.

Les Champs de la Sculpture, *Hyphen Grapes in Comma the Road*, installation, Les Champs-Elysées, Paris, September 15–November 14.

Picard, Denis. "La sculpture revient aux champs [Sculpture returns to the fields]." *Connaissance des Arts* (France) (October 1999): 92–95.

Der Künstler als Kurator: Günter Umberg: . . . und wandelt mit bedächtiger Schnelle vom Himmel durch die Welt der Hölle, Galerie Nächst St. Stephan, Vienna, September 22–October 31. Catalogue, text by Florian Steininger.

Drawing in the Present, Aronson & Main Galleries, Parson School of Design, New York, October 13–December 3.

Think Twice: International Sculpture Show, Galeria OMR, Mexico City, November 9–January 9, 2000.

Geez Louise!: Art After Louise Nevelson, Educational Alliance Gallery, New York, December 2–January 14, 2000. Essay by Natasha Sweeten.

2000

Before They Became Who They Are, Kravets/Wehby Gallery, New York, January 13–February 10.

Spilled Edge/Soft Corner, Blackwood Gallery, University of Toronto at Mississauga, Erindale College, Ontario, Canada, January 14–February 13. Traveled within Canada to Galerie Christiane, Chassay, Montreal, May 13–June 10; Art Gallery of Greater Victoria, Victoria, September 14–December 2; and Kenerdine Art Gallery, University of Saskatchewan, Saskatchewan, January 10–February 17, 2001. Catalogue, text by Barbara Fischer.

Jessica Stockholder: Photography, Bucknell Art Gallery, Bucknell University, Lewisburg, Pennsylvania, January 17–February 18.

Beyond the Press: Innovations in Print, Hand Workshop Art Center, Richmond, Virginia, January 21–February 13.

Sheets, Hilarie. "The Oranges Are Alive." *ARTnews* (March 2000): 118–20.

The Blue Chamber, Duff House, Banff, Scotland, March 4–April 30. Catalogue, text by Iain Irving and Duncan McLean.

Vortex in the Play of Theatre with Real Passion: In Memory of Kay Stockholder and Pictures at an Exhibition, installations, Kunstmuseum St. Gallen, St. Gallen, Switzerland, March 17–June 26. Catalogue.

Restoff, Jörg. "Seherlebnis: St. Gallen: Jessica Stockholder." *Kunstzeitung*, March 9, 2000.

Merz: In the Beginning was Merz: from Kurt Schwitters to the Present Day, *Gelatinous Too Dry*, installation, Sprengel Museum, Hannover, Germany, August 20–November 5. Traveled within Germany to Kunstsammlung Nordrhein Westfalen, Düsseldorf, November 25–February 18, 2001, and Haus der Kunst, Munich, March 9–May 20. Catalogue, text by Dietmar Elger, Isabel Ewig, Justin Hoffmann, Susanne Meyer-Buser, Karin Orchard, and Kurt Schwitters.

The Memory of Painting, Aargauer Kunsthaus, Aarau, Switzerland, August 27–November 19. Catalogue.

Ermen, Rembard. "Das Gedachtnis der Malerei." *Kunstforum International* (Germany) (October–December 2000): 394–96.

Things in Art in the Twentieth Century, *Pictures at an Exhibition*, installation, Haus der Kunst, Munich, September 2–November 26. Catalogue, text by Hubertus Gassner, Axel Hacke, Joachim Jäger, Heinz Lüdeking, Renate Puvogel, Stephanie Rosenthal, Christoph Vitali, Johannes Werner, and Michael Wetzel.

Gebaude: Donald Judd, Gerhard Merz, Jessica Stockholder (with OpenOffice), Heimer & Döring Kunstberatung, Berlin, September 27–November 18.

Skulptur 2000, Kunsthalle Wilhelmshaven, Wilhelmshaven, Germany, October 1–November 12. Catalogue, text by Ute Riese.

Jessica Stockholder, Galerie Nächst St. Stephan, Vienna, December 6–February 3, 2001.

2001

Jessica Stockholder, Galerie Nathalie Obadia, Paris, January 13–March 3.

Pictures, Patents, Monkeys and More . . . On Collecting, organized by Independent Curators Incorporated, New York. Traveled to Western Gallery, Western Washington University, Bellingham, January 19–March 10; John Michael Kohler Arts Center, Sheboygan, Wisconsin, August 12–October 21; Akron Art Museum, Akron, Ohio, November 17–February 18, 2002; Fuller Museum of Art, Brockton, Massachusetts, June 1–August 18; and Institute of Contemporary Art, University of Pennsylvania, Philadelphia, September 4–December 15. Catalogue, text by Ingrid Schaffner, Fred Wilson, and Werner Muensterberger.

Under Pressure: Prints from Two Palms Press, Lyman Allyn Museum of Art at Connecticut College, New London, February 2–April 1. Traveled to The Schick Art Gallery, Skidmore College, Saratoga Springs, New York, July 12–September 16; Meadows Museum, Southern Methodist University, Dallas, October 22–December 8; University Gallery, University of Massachusetts at Amherst, Amherst, February 2–March 15, 2002; and Kent State University Art Gallery, Kent, Ohio, September 4–28. Catalogue, text by Barry Schwabsky.

Objective Color, Yale University Art Gallery, New Haven, Connecticut, February 6–March 25.

Jessica Stockholder, Gorney Bravin + Lee, New York, February 10–March 10.

Chambers, Christopher. "Jessica Stockholder." *Flash Art International* (May/June 2001): 151.

Cotter, Holland. "Review: Jessica Stockholder." *The New York Times*, March 2, 2001, sec. E, p. 37.

D'Souza, Aruna. "Jessica Stockholder at Gorney Bravin + Lee." *Art in America* (October 2001): 157.

Pollack, Barbara. "Jessica Stockholder." *ARTnews* (Summer 2001): 174.

American Art from Sammlung Goetz, Rudolfinum, Prague, May 24–September 2. Catalogue, text by Ursula Frohne, Ingvild Goetz, Noemi Smolik, and Rainald Schumacher.

Camera Works, Marianne Boesky Gallery, New York, June 28–August 10.

SITE Santa Fe's Fourth International Biennial: Beau Monde: Toward a Redeemed Cosmopolitanism, *Bird Watching*, installation, SITE Santa Fe, Santa Fe, July 14–January 6, 2002. Catalogue, text by Dave Hickey.

Douglas, Sarah. "The Layman's Biennial: An Interview with Dave Hickey." *Art Newspaper* (London) (July/August 2001): 22.

Jessica Stockholder, Galerie Nächst St. Stephan, Vienna, September 15–November 10.

The Americans: New Art, Barbican Gallery in London, London, October 25–December 23. Catalogue, text by Bruce Hainley, Katy Siegel, Bennett Simpson, John Slyce, and Mark Sladen.

Ryan, David. "Jessica Stockholder: the theatre of the inferred." *Contemporary Visual Arts* (U.K.), no. 32: 30–35.

2002

Jessica Stockholder, Galleria Raffaela Cortese, Milan, January 18–March 30.

Beatrice, Luca. "Stockholder: in search of the casual." *Arte* (Italy) (February 2002): 65.

Moratto, Rossella. "Le Construzioni di Jessica Stockholder." *Art & Job Magazine* (February 27, 2002).

Beyond the Pale: Material Possibilities, Neuberger Museum of Art, State University of New York, Purchase, February 3–May 26.

Painting Matter, James Cohan Gallery, New York, May 3–June 1.

Art Downtown: New Photography, Wall Street Rising, New York, June 13–September 15.

Jessica Stockholder, Baltic Art Center, Visby, Sweden, June 15–September 1.

New Editions and Monoprints, Pace Prints, New York, June 19–July 12.

TRESPASSING: Houses x Artists, organized by OpenOffice, in conjunction with Bellevue Art Museum, Bellevue, Washington, August 31–January 5, 2003, and M.A.K Center for Art and Architecture, Los Angeles, January 29–July 27. Traveled to Contemporary Art Museum, University of South Florida, Tampa, August 30–October 17, and Blaffer Gallery, the Art Museum of the University of Houston, Houston, January 17–March 14, 2004. Catalogue, text by Kevin Appel, Peter Noever, Kathleen Harleman, Cara Mullio, and L. D. Riehle.

On the Spending Money Tenderly, installation, Kunstsammlung Nordrhein-Westfalen, Düsseldorf, Germany, December 1–March 9, 2003.

Müller-Tamm, Pia. "Jessica Stockholder: On the Spending Money Tenderly, Eine Installation in K20 Kunstammlung Nordrhein-Westfalen." *Vernissage* (Amsterdam) (Winter 2002): 14–15.

Puvogel, Renate. "Jessica Stockholder." *Artforum* (January/February 2003): 300–302.

Jessica Stockholder, Stiftung Wilhelm Lehmbruck Museum, Duisburg, Germany, December 1–January 26, 2003. Catalogue.

Leinz, Gottlieb. "Jessica Stockholder: Jenseits der Malerei, Duisburg." *Vernissage* (Amsterdam) (Winter 2002): 4–13.

SiteLines: Art on Main, Addison Gallery of American Art, Phillips Academy, Andover, Massachusetts, ongoing project with high school students, includes eight other artists.

2003

Jessica Stockholder, Gallery Rolf Ricke, Cologne, March 14–April 17.

Jessica Stockholder Prints, Chelsea Art Museum, New York, April 5–May 2.

Yablonsky, Linda. "Even the Kitchen Sink." *ARTnews* (May 2003): 137–39.

TV Tipped Toe Nails & the Green Salami, installation, capc Musée d'art contemporain de Bordeaux, Bordeaux, France, June 12–September 21. Catalogue, text by Maurice Fréchuret and Thierry Davila.

Table Top Sculpture, Gorney Bravin + Lee, New York, October 10–November 15.

Avgikos, Jan. "Art Reviews: Jessica Stockholder." *Artforum* (December 2003): 144–45.

Dannatt, Adrian. "Contemporary Commercial Galleries: Jessica Stockholder Table Top Sculpture." *The Art Newspaper* October 2003, p. 3.

Levin, Kim. "When a 'Tender Collision' Becomes an Artist's 'Situation.'" *The Village Voice*, October 31, 2003.

Yablonsky, Linda. "Art Reviews: Jessica Stockholder." *Time Out/New York* (October 23–30, 2003): 79.

ARTIST'S ACKNOWLEDGMENTS

I would like to thank Terrie Sultan and Nancy Doll for organizing this publication and the traveling exhibition that it accompanies. It has been a real pleasure to work with them and to have the opportunity to fully explore this aspect of my work. I also want to thank Karin Bravin, Jay Gorney and John Post Lee for their support. Sheri Pasquarella at Gorney Bravin + Lee deserves special acknowledgment for her help in managing all the small details of my archive. I am also grateful to Yale University for encouraging the productivity of its faculty, as well as my husband, Patrick Chamberlain, and my son, Charlie Chamberlain, for their constant support and love.

Nancy M. Doll is Director of the Weatherspoon Art Museum, The University of North Carolina at Greensboro. Her most recent publication is *One Word: Plastic* (Greensboro, N.C.: Weatherspoon Art Museum, 2003), and she is a contributing author to *Fields of Dreams* (publication pending), PULSE-2 (Seattle: University of Washington Press, 1990), and *Santa Barbara Museum of Art: Selected Works* (Santa Barbara, Calif.: Santa Barbara Museum of Art, 1991).

Elspeth Carruthers is Assistant Professor in the Department of History at the University of Illinois–Chicago. Her scholarly interests are in medieval agriculture, law, cartography, and environmental history, and she is working on a book about the German colonization of the southern Baltic area in Eastern Europe during the later Middle Ages.

Terrie Sultan is Director and Chief Curator of Blaffer Gallery, the Art Museum of the University of Houston. She has written extensively about contemporary art and culture. Her publications include *Chuck Close Prints: Process and Collaboration* (Princeton, N.J.: Princeton University Press, 2003), *Donald Lipski: A Brief History of Twine* (New York: D.A.P./Distributed Art Publishers, Inc., 2000), and *Kerry James Marshall* (New York: Harry N. Abrams, Inc., 2000).

Miwon Kwon is Associate Professor in the Department of Art History at the University of California, Los Angeles. Her research and writings engage several disciplines including contemporary art, architecture, public art, and urban studies. She is the author of *One Place after Another: Site-Specific Art and Locational Identity* (Cambridge, Mass.: MIT Press, 2002).